Persian Poetry, Painting & Patronage

Persian Poetry, Painting & Patronage

Illustrations in a Sixteenth-Century Masterpiece

MARIANNA SHREVE SIMPSON

Freer Gallery of Art
Smithsonian Institution, Washington, D.C.
Yale University Press, New Haven and London

Published in 1998 by Yale University Press, New Haven and London
in association with the Freer Gallery of Art, Smithsonian Institution,
Washington, D.C.

Edited by Ann Hofstra Grogg
Designed by Derek Birdsall RDI
Typeset in Monotype Poliphilus with Blado Italic by Omnific Studios
Printed in Italy by Amilcare Pizzi S.p.A.

Library of Congress Cataloging-in-Publication Data

Simpson, Marianna Shreve, 1949-
 Persian poetry, painting & patronage : illustrations in a
 sixteenth-century masterpiece / Marianna Shreve Simpson.
 p. cm.
 Includes bibliographical references (p.) and index.
 ISBN 0-300-07483-2 (cloth)
 1. Jāmī, 1414-1492. Haft awrang—Illustrations. 2. Freer Gallery
 of Art. Manuscript. 46. 12—Illustrations. 3. Illumination of
 books and manuscripts, Iranian. 4. Illumination of books and
 manuscripts, Islamic—Iran. 5. Illumination of books and
 manuscripts—Washington (D.C.) I. Title.
 ND3399.J35S56 1997
 745.6'7'0955—dc21 97-41288
 CIP

*Cover: The Aziz and Zulaykha Enter the Capital of Egypt and
the Egyptians Come Out to Greet Them* (folio 100b, detail)

CONTENTS

Even at the end of this image-rich and media-saturated century, illustrated books from Islamic lands, particularly those from the Persian world, continue to hold a special fascination for both scholar and the general public alike. Hundreds of years after their creation, these books, with their unique and sophisticated linkage of word, image, and ornament, still draw viewers into an aesthetic realm unlike any in the history of art. Perhaps not surprisingly, how this visual landscape was constructed and the ways in which its mechanics, conceptual parameters, and visual dynamics worked remain elusive after a century of scholarship.

Our understanding of this tradition has in recent years moved toward approaches that attempt broader cultural and aesthetic interpretations of Persian painting and manuscript production. *Sultan Ibrahim Mirza's Haft awrang: A Princely Manuscript from Sixteenth-Century Iran* (Yale University Press, 1997) reflects both these recent intellectual realignments and the continuing role of research and scholarship at the Freer Gallery of Art and Arthur M. Sackler Gallery. This publication, *Persian Poetry, Painting & Patronage: Illustrations in a Sixteenth-Century Masterpiece*, is a condensed summary of the much larger monograph, and focuses particularly on its outstanding paintings. The entire project represents more than a decade of research and thought by Dr. Marianna Shreve Simpson, formerly the Galleries' curator of Islamic Near Eastern art, and her efforts represent an important new contribution. Chief among these has been her emphasis on Persian manuscript paintings not as single, independent works of art but as parts of a larger collaborative ensemble—the book. By reexamining from this perspective a particularly rich and pivotal moment in the history and development of Persian painting under the Safavid dynasty (1501–1736), she has produced a comprehensive, meticulous analysis of both the physical and conceptual totality of a single royal manuscript. It is testimony to the complexity of issues inherent in the study of these works as well as the earlier priorities of the field that very few illustrated Islamic manuscripts have been published in their entirety, a state quite at odds with scholarship for European manuscripts. Dr. Simpson's research begins to help close that gap in its skillful documentation of the creation of one of the most important illustrated Persian manuscripts in existence. Acquired by the Freer Gallery of Art in 1946 by its then director Archibald Wenley, the Freer Jami is recognized not simply as a beautiful object but as a critical cultural document.

This study, cast in the form of a vigorous codicological inquiry, has produced for the first time a clear picture of how the book was conceived, written, painted, decorated, and bound. Dr. Simpson brings to these issues a deep knowledge of manuscript production and dissemination in the Persianate cultural sphere, particularly the structure and function of artistic ateliers (*kitabkhanas*) in Safavid Iran. And while important new information has also been gathered on a host of artists and calligraphers, the author's greatest contribution is her careful analysis of the respective, interlinked roles played by text, painting, and illumination in Islamic visual thought. It is through careful exploration of avenues such as these that we will begin to understand how a culture both saw itself and how it wished to be seen by others.

Dr. Simpson's research was supported by the Smithsonian Institution's Scholarly Studies Program and the National Gallery of Art's Center for Advanced Study in the Visual Arts. *Sultan Ibrahim Mirza's Haft awrang* was published with the assistance of the Getty Grant Program. Additional funding was provided by the Freer and Sackler Galleries' Publications Endowment Fund, initially established with a grant from the Andrew W. Mellon Foundation and generous contributions from private donors. For consultation, guidance, and thoughtful, sustained effort, the Freer Gallery also thanks Thomas W. Lentz, deputy director; Massumeh Farhad, associate curator of Islamic Near Eastern art; Karen Sagstetter, editor in chief; John Nicoll, managing director, Yale University Press; Derek Birdsall, designer; and Ann Hofstra Grogg, editor. The many other contributors to the research and publication are mentioned in the preface to *Sultan Ibrahim Mirza's Haft awrang*, the monograph upon which this book is based.

Milo Cleveland Beach
Director, Freer Gallery of Art and Arthur M. Sackler Gallery
Smithsonian Institution

This publication summarizes research undertaken on a major work of art in the Islamic collection of the Freer Gallery of Art and presented more completely in *Sultan Ibrahim Mirza's Haft awrang: A Princely Manuscript from Sixteenth-Century Iran* (Yale University Press, 1997). Both the monographic study and this shorter version have been inspired and influenced by two esteemed specialists of Islamic art. It was the brilliant connoisseurship of Stuart Cary Welch, curator emeritus of Islamic and later Indian art at Harvard University, that initially opened my eyes as a graduate student to the dazzling beauty of Persian painting and to the creativity of sixteenth-century court artists and patrons. His seminal publications on the Safavid period, including the magisterial *Houghton Shahnameh* co-authored with Martin B. Dickson, have provided continual stimulus throughout my investigations into the *Haft awrang* manuscript and its princely patron. Imitation being the sincerest of flattery, the format of this book is modeled on Cary Welch's ever-invaluable *Persian Painting: Five Royal Safavid Manuscripts of the Sixteenth Century* (Braziller, 1976).

I first turned the folios of Sultan Ibrahim Mirza's *Haft awrang* at the encouragement of Esin Atil, former curator of Islamic art at the Freer Gallery of Art, who has made many other wonderful experiences possible for me over the years. Esin Atil remains my museum mentor, and I am deeply indebted to her for continual, gentle guidance in how to look at and think about works of Islamic art.

I am also grateful to Richard and Loren Kagan for their unconditional interest and support.

Marianna Shreve Simpson
Baltimore, Maryland
February 1997

Overleaf:
Gold-flecked page (folio 182a)

PART I. PERSIAN POETRY, PAINTING & PATRONAGE:
SULTAN IBRAHIM MIRZA'S *Haft awrang*

Poetry and painting have long been allied in the arts and culture of Iran (also known as Persia). Since at least the twelfth century, Persian poets have woven verses out of pictorial imagery, while Persian painters of the late thirteenth century through early modern times composed illustrations intended to evoke poetic contents, mood, and meaning. Over the centuries this union of the literary and visual arts was forged through the intermediary of royal patrons, including the rulers and princes of Iran's leading dynasties, who commissioned deluxe copies of classical poetic texts. The taste for and patronage of the twin arts of literature (including poetry) and the book (including calligraphy, decoration, painting, and binding) resulted in the creation of some of the greatest masterpieces of Persian culture.

The remarkable results that could be achieved through the alliance of poetry, painting, and patronage in Iran are exemplified by a famous illustrated manuscript belonging to the Freer Gallery of Art and commonly known as the Freer Jami (accession number 46.12). The volume contains seven poems collectively entitled the *Haft awrang* and called in English the *Seven Thrones* or *Constellation of the Great Bear*, which were composed by Abdul-Rahman Jami, a celebrated fifteenth-century poet, scholar, and mystic. In the middle of the sixteenth century Sultan Ibrahim Mirza, a young princely patron of the reigning Safavid dynasty (1501–1732) with a penchant for Jami's poems, engaged a group of gifted artists to transcribe, illuminate, and illustrate a special copy of the *Haft awrang*. The making and meaning of Sultan Ibrahim Mirza's splendid commission—and particularly of its twenty-eight illustrations—constitute a fascinating story that reveals the many ways that painting and poetry formed essential complements in traditional Persian culture.

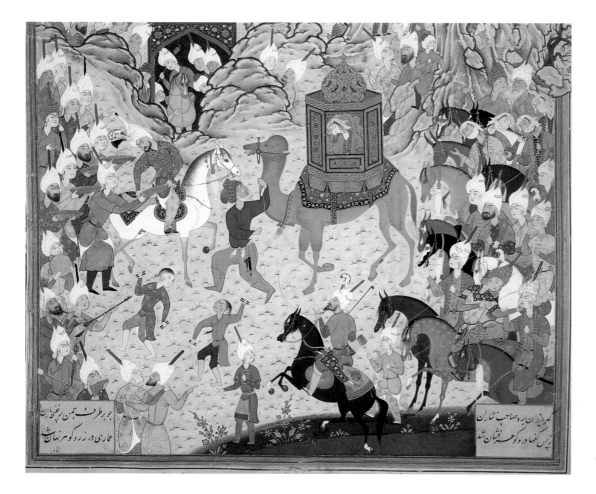

The Aziz and Zulaykha Enter the Capital of Egypt and the Egyptians Come Out to Greet Them (folio 100b, detail)

9

THE ACCOUNT OF the Freer Jami begins in the 1460s–1480s when Abdul-Rahman Jami (1414–1492) wrote the seven poems that make up the *Haft awrang*. At that time Jami was a prominent author and spiritual leader in Herat, capital of the then-ruling Timurid dynasty (1370–1506) and seat of its last and most cultivated ruler Sultan-Husayn Mirza. During his long reign (1470–1506), Sultan-Husayn Mirza patronized many of the literary and artistic elite of the Timurid period and fostered a climate in which poets and painters produced works that today remain landmarks of Persian literature and art.

The poems of the *Haft awrang* rank high among these landmarks and among the most memorable works of Abdul-Rahman Jami's considerable oeuvre. All seven are written in a Persian poetic form called *masnavi*, comprising a sequence of couplets that rhyme in pairs. Persian poets commonly used the *masnavi* form for narrative (including heroic, historic, and romantic epics) and didactic poetry. Three of the *Haft awrang* poems are allegorical romances and bear the names of their main characters: *Yusuf and Zulaykha*, *Salaman and Absal*, and *Layli and Majnun*. Another three—*Silsilat al-dhahab* (Chain of gold), *Subhat al-abrar* (Rosary of the pious),

and *Tuhfat al-ahrar* (Gift of the free)—consist of a series of didactic discourses, while the seventh—*Khiradnama-i Iskandari* (Iskandar's book of wisdom)—combines epic and didactic genres.

The precise genesis of the *Haft awrang* is uncertain. We do not know, for instance, if Abdul-Rahman Jami began to compose the poetic text at the behest of Sultan-Husayn Mirza, although the poet obviously sought to please the Timurid monarch by writing four of the seven individual poems in his honor. Following time-honored tradition, Jami drew heavily upon the writings of earlier poets, particularly Nizami of Ganja (1141–1209), for the concept and format of the multipoem *Haft awrang*. The themes and messages of his *masnavis*, on the other hand, are based on spiritual, philosophical, and ethical ideas of Sufism, a mystical branch of Islam. More specifically, Jami grounded his poetry in the beliefs and attitudes of the Naqshbandiyya, a Sufi order or brotherhood that he had joined at a young age. In 1456 Jami rose to assume the dual position of *pir* (master) and *murshid* (leader) of the Naqshbandi order in Herat.

When, about 1468, Jami began writing the *Haft awrang*, his principal concern was to explore and express certain key ideas of Sufi Islam. In Sufi

Illuminated title piece to *Salaman and Absal* (folio 182b)

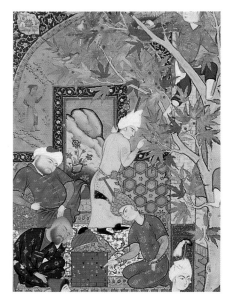

A Father Advises His Son about Love (folio 52a, detail)

Opposite:
Text folios of *Yusuf and Zulaykha* (folios 98b–99a)

mystical doctrine God is manifest everywhere and is the sole and absolute source of beauty, truth, purity, goodness, wisdom, and, most important, love. The material and phenomenal world is but a mere reflection of God's perfection, and the goal of every adherent of Sufi orders like the Naqshbandiyya is to be spiritually reborn in the unity of God. The Sufi mystic struggles constantly to transcend daily human sensations and physical experiences and to achieve a state of true being through the selfless, all-embracing love of God. Jami's own commitment to the Sufi ideal of divine perfection and spiritual perfectibility resonates throughout the *Haft awrang* and helps unify the seven separate *masnavis*.

Like that of other Sufi writers, Jami's language is rich in metaphorical images and mystical symbols that are open to a wide range of interpretation. Jami evidently recognized that his discussions of abstract ideals, particularly in *Silsilat al-dhahab*, *Tuhfat al-ahrar*, and *Subhat al-abrar*, might not be easy to follow. Thus he emphasized the didactic points of these particular poems and framed his discussion of philosophical and ethical issues with a sequence of anecdotal stories and illustrative parables. Usually succinct, these passages feature human and animal characters and bracket one or more longer discourses to which they relate thematically. Although their presence and purpose are most apparent in the three didactic *masnavis*, stories and parables are also prominent within *Salaman and Absal* and *Khiradnama-i Iskandari*.

Jami undoubtedly conceived these anecdotal interludes as instructive devices for those who would read the *Haft awrang*. Yet they subsequently proved to be equally important for artists who had to illustrate the poet's complex *masnavis*. The pictorial cycles of *Silsilat al-dhahab*, *Tuhfat al-ahrar*, and *Subhat al-abrar*, for instance, consist exclusively of representations of the stories that help structure the poems and reinforce the moralizing message of the discourses. Even the illustrative programs to *Salaman and Absal* and *Khiradnama-i Iskandari* include paintings of the secondary illustrative tales instead of scenes of the primary narrative episodes.

For most works of classical Persian poetry there was a considerable hiatus between the time of their literary creation and the time of their painted illustration. The earliest known illustrated volume of the *Khamsa* (Quintet) of Nizami Ganjavi, for example, dates several hundred years after its composition. The *Haft awrang*, on the other hand, seems to have been illustrated during Abdul-Rahman Jami's lifetime, as attested by a copy of the *Yusuf and Zulaykha* poem dated July 1488 and containing two spaces reserved for paintings: one contains a preliminary sketch representing Yusuf and Zulaykha in Zulaykha's palace.[1] Curiously—although perhaps not coincidentally—this date accords precisely with that of a poetic manuscript, the *Bustan* (Orchard) of Sa'di, made in Herat for the Timurid ruler Sultan-Husayn Mirza and illustrated with beautiful compositions by Bihzad, a famous painter of the period. One of Bihzad's paintings depicts Zulaykha attempting to seduce Yusuf in her palace—the very scene planned for the *Yusuf and Zulaykha* manuscript of 1488.[2] While Bihzad was ostensibly illustrating a text by Sa'di, a thirteenth-century poet, he may have been more immediately inspired in his conception and rendition of the scene by the mystical version of the Yusuf and Zulaykha tale written by his contemporary Jami. Similarly, the presence of Bihzad and other talented artists in Herat during the time Jami was composing his *masnavis* doubtless led the poet to appreciate the value of paintings in conveying the messages of his *Haft awrang*. Certainly the court of Sultan-Husayn Mirza provided the right setting for poetry and painting to combine in the initial illustration of a new literary "classic" such as Jami's *Haft awrang*.

IT HAS BEEN said that Jami's popularity and fame began to wane after his death in 1492 and especially after the Safavids, a dynasty with no tolerance for the Naqshbandiyya, took control of Iran in 1501. The first Safavid ruler, Shah Isma'il I (reigned 1501–24), supposedly hated Jami so much that he planned to destroy the poet's tomb in Herat. Notwithstanding the shah's reported censure, the practice of illustrating Jami's *masnavis* continued and became well established in Iran by the early part of the sixteenth century. Illustrated volumes of the *Haft awrang* were produced with great regularity throughout the Safavid period, and at least two hundred manuscripts—including compilations of all seven poems, selections of multiple poems, and individual poems—are now known. Of these the manuscript commissioned by Shah Isma'il's grandson, Sultan Ibrahim Mirza—who was clearly undeterred by his grandfather's negative attitude toward Jami—contains by far the most ambitious and innovative pictorial program. Indeed in all its artistic features—calligraphy, illumination, and illustration—the Freer Jami is without a doubt the most beautiful copy of the *Haft awrang* that has come down to us today.

As a prince of the Safavid dynasty, Sultan Ibrahim Mirza (1540–1577) came quite naturally by his interest and involvement in the arts, and particularly poetry and painting. Virtually every member of his family (both male and female) was accomplished as a calligrapher and poet and active in the patronage and collecting of art. Following the death of his father Bahram Mirza in 1549, Sultan Ibrahim Mirza was raised at the court of his uncle Shah Tahmasp, the second Safavid ruler (reigned 1524–76), in Tabriz. There the prince was trained in a wide range of spiritual and secular subjects from the reading and recitation of the Koran to musical composition. According to Qazi Ahmad, a contemporary historian and admirer of the prince, Sultan Ibrahim Mirza also excelled in "poetical criticism, the solution of fine points of versification and nuances of Sufism and love."[3] Under the pen-name Jahi, Sultan Ibrahim Mirza composed verses in Persian and Turkish; at least two posthumous copies of his *Divan* (Poems) survive today.[4] Qazi Ahmad also extols the prince for his "golden hands in painting in decorating" and for his mastery of "bookbinding, gilding, gold-sprinkling, the making of stencils and the mixing of colors."[5] The prince's real forte seems to have been in calligraphy, and Qazi Ahmad praises him for the ability to write in both large and fine scripts.[6]

Sultan Ibrahim Mirza would have received encouragement for all these artistic pursuits from Shah Tahmasp, who apparently took a special interest in his young nephew's education. Furthermore, during his formative years in Tabriz, Ibrahim Mirza would have come in contact with—and possibly even taken instruction from—the many artists employed at the royal court. During the early decades of his long reign, Shah Tahmasp was an avid patron of the arts and sponsored a *kitabkhana* (literally, "book house," but actually signifying both artistic studio and library) where numerous calligraphers, painters, illuminators, binders, and other specialists created deluxe volumes of classical Persian texts. Among the splendid works in process at Tahmasp's *kitabkhana* when Sultan Ibrahim Mirza came to his uncle's court was the *Khamsa* of Nizami, transcribed by the great calligrapher Shah-Mahmud al-Nishapuri and embellished with illustrations by a half-dozen or so brilliant painters.[7]

In 1554–55 Shah Tahmasp appointed Sultan Ibrahim Mirza, then sixteen years of age, to be governor of the important city of Mashhad, site of the venerable shrine of the Imam Reza, in the northeastern Iranian province of Khurasan. According to Qazi Ahmad, "The shah honored Ibrahim Mirza with th[is] position among the people of knowledge" and, in a final mark of his regard and expectations, gave the prince a retinue of about five hundred courtiers, bodyguards, and noblemen "whom he had selected one by one for their esteem and dignity."[8] The prince and his handpicked entourage seem to have made a leisurely journey to Mashhad, arriving there on 19 March 1556.

Sultan Ibrahim Mirza's appointment to Mashhad more or less coincided with arrangements for his marriage to Gawhar-Sultan Khanim, the eldest daughter of Shah Tahmasp. As with the governorship, this marriage between the prince and his cousin was arranged, or at least agreed upon, by the shah himself. One Safavid historian reports that Tahmasp selected Gawhar-Sultan as his nephew's bride because of her superior intelligence, beauty, and wisdom.[9] The precise date of the marriage is difficult to determine, but it seems to have been preceded by a lengthy betrothal and celebrated in Mashhad with festivities lasting several months during the spring and summer of 1560.

By this time Sultan Ibrahim Mirza's most important work of patronage—the *Haft awrang* manuscript known today as the Freer Jami—was already well under way. While contemporary sources offer no hint of a connection between the prince's commission and his appointment to Mashhad and marriage to Gawhar-Sultan Khanim, his *Haft awrang* contains several compositions illustrating marital and amorous themes. Of these, two illustrations in the *Yusuf and Zulaykha* poem—*The Aziz and Zulaykha Enter the Capital of Egypt and the Egyptians Come Out to Greet Them* (folio 100b) and *Yusuf Gives a Royal Banquet in Honor of His Marriage* (folio 132a)—suggest the most obvious parallels to events, including arrival ceremonies and wedding festivities, recorded at the time of Sultan Ibrahim Mirza's marriage to Gawhar-Sultan Khanim. (These and all paintings in the Freer Jami are illustrated and discussed in Part 2, arranged by folio number.) Indeed, Sultan Ibrahim Mirza may have had the possibility of marriage to Gawhar-Sultan Khanim in mind while planning the pictorial program of his magnificent *Haft awrang*.

Illuminated title piece to *Yusuf and Zulaykha*, signed by Abdullah al-Shirazi (folio 84b)

WHATEVER THE PRINCE'S motivations, his commission of an illustrated volume of the *Haft awrang* turned out to be an extremely ambitious, protracted, and even far-flung undertaking. As recorded in the colophons, or scribal notations at the end of each of the *masnavis*, the transcription or copying of the text alone took nine years—from 1556 to 1565—and involved the participation of no less than five calligraphers working in three different Iranian cities (see Chronology). Furthermore, the sequence of the *masnavis* in the volume does not follow the chronological order of their transcription. The format of the manuscript's 304 folios is also complicated, with the written surface composed of one piece of cream paper and the margins of another piece of colored paper. Thus we may surmise from the codicology or material structure of the manuscript that its production was a complex process, requiring careful planning and coordination.

Several inscriptions in the Freer Jami document that the volume was made "by order of the *kitabkhana* of Abu'l-Fath Sultan Ibrahim Mirza" (folios 38b and 162a), and the historian Qazi Ahmad confirms that, like his uncle Shah Tahmasp, the Safavid prince supported a *kitabkhana* with numerous artists during his time as governor of Mashhad.[10] From two of the Freer Jami colophons as well as the primary sources we know that the head of the *kitabkhana* was a calligrapher named Muhibb-Ali, who undoubtedly helped Sultan Ibrahim Mirza develop the material and artistic program for the *Haft awrang*. As *kitabdar*, or *kitabkhana* chief, Muhibb-Ali also would have been responsible for the preparation of all the necessary materials, including the two sets of paper used for the folios,

and for the selection and supervision of the *kitabkhana* staff. It is possible that Sultan Ibrahim Mirza originally intended Muhibb-Ali to copy the entire Jami text, as suggested by the calligrapher's transcription of two of the seven poems of the *Haft awrang*. Either the prince or his *kitabdar* may have decided early on to expand the calligraphic ranks of the *kitabkhana* and take advantage of the opportunity to engage Shah-Mahmud al-Nishapuri, the celebrated (and by 1556 quite elderly) scribe of Shah Tahmasp's *Khamsa*, who had moved from the Safavid court to Mashhad several years before Sultan Ibrahim Mirza assumed the governorship there. Muhibb-Ali eventually enlisted three other calligraphers to transcribe certain parts of the Freer Jami text—Rustam-Ali, Malik al-Daylami, and Ayshi ibn Ishrati—as well as the illuminator Abdullah al-Shirazi, who signed his name in the elaborate title piece or illumination at the head of the *Yusuf and Zulaykha* poem.

Abdullah would have been but one of scores of illuminators who worked on the *Haft awrang* project under Muhibb-Ali's supervision. In addition to *masnavi* headings and colophons, the Freer Jami boasts a dazzling array of decoration, including multicolored rubrics or chapter headings, gold column dividers, and gold-painted and stenciled margins. These illuminated features appear on virtually every folio of the manuscript and contribute significantly to its overall aesthetic. The sheer quantity of the illumination as well as subtle variations of design and form tell us both that the decorative program involved many different illuminators and that these artists undoubtedly worked in teams responsible for different sections of the manuscript.

Colophon of *Silsilat al-dhahab*, signed by Malik al-Daylami (folio 46a)

Text folio of *Subhat al-abrar* (folio 179a)

The transcription and illumination of the text constituted two distinct—and probably overlapping—phases in the creation of Sultan Ibrahim Mirza's *Haft awrang*. The illustration represented yet a third phase and clearly involved a large number of painters. Although one composition is signed (folio 120a), modern scholarship has yet to reach a consensus on the attribution of the full set of paintings and the identity of their artists. The originality and quality of the illustrations correspond, however, to the highest standards of Safavid period painting, and we may assume that, like the calligraphers, some and perhaps even all of the Freer Jami painters had previously worked, or at least been trained, at the Safavid court.

The twenty-eight compositions in the Freer Jami belong to the so-called classical tradition of Persian painting that emerged in the second half of the fourteenth century, matured throughout the fifteenth, and produced some of its most memorable achievements during the late Timurid and early Safavid periods. The principal stylistic characteristics of this tradition include large-scale compositions that frequently overflow into the surrounding margins; a bright and extensive palette of jewel-like (and often precious) pigments polished to a high sheen; fluid, rhythmic lines; deliberate modeling of forms; expansive architectural and landscape settings; elegant, idealized figures in gorgeous attire; diverse flora and fauna; and intricate ornamental patterns used on textiles (including costumes, carpets, tents, and canopies) and buildings (especially brick, tile, and woodwork). Full of exciting pictorial contrasts, the classical style of Persian painting deftly juxtaposes the ideal and fantastic (sometimes even the mystical) with the everyday, mixes rigorous control and decorum with the earthy and ribald, and matches a calculated sense of space with illogical proportions. Perhaps the style's most pervasive and palpable feature is its sense of energy, and many of the most remarkable Persian paintings of the late fifteenth and sixteenth centuries positively throb with life.

The illustrations in the Freer Jami partake directly of this vital stylistic mode. Furthermore they regularly combine familiar pictorial elements with those that are new and innovative. While certain formal features may result from the creativity of individual artists, others pervade the entire manuscript and are found in paintings unlikely to be by the same artistic hand. Thus we may regard the twenty-eight compositions as reflecting an approach toward painting peculiar to this manuscript and subscribing to the tastes and expectations of its patron Sultan Ibrahim Mirza.

With the exception of the initial painting (folio 10a), the Freer Jami compositions all occupy the full space of the manuscript's written surface, and most are considerably larger. In addition, most take advantage of their generous picture planes, often with extremely complex arrangements of settings and figures. As in most classical Persian painting, the Freer Jami illustrations reflect certain typologies and formulas. A few scenes replicate, or at least closely follow, well-established compositional models. The most obvious instance is *The Mi'raj of the Prophet* (folio 275a), in which the Prophet Muhammad rides on his human-headed steed Buraq through a celestial firmament populated by a host of angels with Gabriel in the lead. *The Flight of the Tortoise* (folio 215b) also belongs to a specific compositional scheme that can be traced back several centuries. Other compositional elements are more generic, such as the battle dominating *Bandits Attack the Caravan of Aynie and Ria* (folio 64b) and the core figure group in *The Pir Rejects the Ducks Brought as Presents by the Murid* (folio 153b), which is derived from a common topos or formula for a prince visiting a hermit.

In addition, many specific personages in the Freer Jami emerge from the figural repertoire of classical Persian painting. Among the most familiar individuals are the washerwoman and milkmaid (folios 30a and 231a), the languid youth (folios 52a, 105a, and 147a), the woodsman (folios 110b and 253a), the second-story observers or hilltop onlookers (folios 120a, 162a, 188a, 207b, and 291a), the eager attendants (folios 132a and 291a), the gardener with a spade (folios 52a and 207b), the aged petitioner (folio 188a), and the grief-stricken mourners (folio 298a).

Yet for every set compositional unit and fixed figure type, the Freer Jami offers something unexpected, typically a fresh way of conveying a familiar visual theme. For instance the bathhouse or *hammam* of *The Dervish Picks Up His Beloved's Hair from the Hammam Floor* (folio 59a) is conceived as a multichambered structure and presented in sectional elevation. Bathers and bath attendants enter the building's doorways and move through its passageways, thus emphasizing the unified architectural space. The sense of interior versus exterior is further enhanced by the projecting facade and waiting horse and groom at the left, a device employed to similar advantage in the illustration featuring King Solomon and the queen of Sheba (folio 188a). The many outdoor scenes, where palaces, pavilions, and other habitats such as tents are often situated in lush settings, also provide extended space and perspectival schemes. By juxtaposing open plain, craggy hills, and intricate facades and rooftops, the first illustration in the *Yusuf and Zulaykha* poem conveys the expanse and richness of the domains belong to the *aziz* (minister) of Egypt and the imminent progression of Zulaykha and her bridal party into the Egyptian capital (folio 100b).

Another pervasive feature of the Freer Jami compositions is their multiple focuses. These not only provide the field for diverse action but also encourage much visual "wandering" through the pictures and consequent diversion from the principal scene. It is easy at first to overlook, for instance, the negotiations between the peasant and the donkey seller in *The Simple Peasant Entreats the Salesman Not to Sell His Wonderful Donkey* (folio 38b) while listening in on the baker and his elderly customer at the side of the bazaar or cantering along in front with the dappled horse and its elegant rider. It is equally possible to miss the man mounting the camel in *A Depraved Man Commits Bestiality and Is Berated by Satan* (folio 30a) while enjoying the acrobats, musicians, and children encamped above. *Majnun Approaches the Camp of Layli's Caravan* (folio 253a) presents the most extreme example of the artistic tendency, found throughout the Freer Jami, to overload the compositions. Here the eye is so inexorably led along switchbacks and into cul-de-sacs, past curious, even bizarre, exchanges and spatially ambiguous and improbable situations that the pathetic figure of Majnun at the left side can be missed altogether.

Beyond such imaginative and distracting schemes, the most compelling characteristic of the Freer Jami paintings is their high level of human interest, sustained through the activities and emotions, the number and diversity of the principal and secondary figures. As an aggregate, the Freer Jami compositions present a wide range of human experience, from sexual intercourse (folio 30a), to imminent death (folio 298a), passing by way of spiritual apotheosis, revelation, and prayer; commercial transactions; domestic chores (preparing food, washing clothes, spinning and sewing, gathering firewood); animal husbandry (milking cows, watering and feeding horses and camels); intellectual interests (chess and reading); and entertainment and leisure (music and games). Also regularly encountered are expressions of love and devotion, anger, amazement, self-doubt, fear, incredulity, and censure.

The population of the Freer Jami is equally diverse. *The Aziz and Zulaykha Enter the Capital of Egypt and the Egyptians Come Out to Greet Them* (folio 100b), for instance, contains more than one hundred figures, plus several "hidden" rock-face creatures, who take part in many different ways in the meeting between Zulaykha and the *aziz* of Egypt. Most figures in the illustrations are extraneous to the central scene, such as the embroidering woman who seems totally oblivious to the amazing scene taking place over her head in *The Flight of the Tortoise* (folio 215b). Sometimes the figures are not so easy to identify or explain, such as the blind beggar and his young companion in the middle of a battle scene (folio 64b). There is, in fact, a certain, apparently deliberate, level of human ambiguity and mystery in many of these compositions.

The cast of supplemental characters in the Freer Jami includes a plethora of children, including several babes in arms. Only one illustration to the *Yusuf and Zulaykha* poem requires the presence of a child, the infant who miraculously testifies to the innocence of the prophet Yusuf (folio 120a). Here, however, the infant-witness resembles a small adult, whereas the other Freer Jami children are convincingly portrayed and engaged in playing, shopping, and general merriment (folios 30a, 38b, and 52a). Sometimes their activities are more serious, such as the boy leading the blind beggar in *Bandits Attack the Caravan of Aynie and Ria* (folio 64b), or less certain, such as the young girl who may be trying to restrain an older female at the left side of *Majnun Approaches the Camp of Layli's Caravan* (folio 253a). Many family groupings include mothers suckling and cuddling babies and tending young children (folios 30a, 110b, 169b, 188a, and 231a) as well as two or three clearly identifiable or probable fathers (folios 38b, 52a, 179b, and 231a) and possibly even a grandmother (folio 38b). Nurturing and caretaking are also implicit in *The Wise Old Man Chides a Foolish Youth* (folio 10a) and explicit in *Yusuf Tends His Flocks* (folio 110b), where a dappled mare nurses her foal virtually alongside a human mother hugging her child.

Particular landscape features also regularly appear in the Freer Jami and form part of its special style. As in all Safavid painting, the outdoor scenes, here constituting three-quarters of the illustrations, include many tall, leafy trees. Throughout the Freer Jami the *chinar* or plane tree predominates and provides a home to flocks of birds and their nests. Although sometimes simply an attractive landscape element, most plane trees serve a significant compositional and iconographic function. The most active and dramatic roles are played by the tree with the twisted trunk and whirligig leaves that shelters Layli and her flock in *Majnun Comes before Layli Disguised as a Sheep* (folio 264a) and the massive stumps that burst into flames as Iskandar is laid down in the final illustration (folio 298a). Other trees provide essential vantage points (folio 100b), encourage mischief-making (folio 52a), shelter domestic activities (folios 30a, 105a, 110b, and 231a), and anchor the scene (folios 38b and 64b).

Also noteworthy are the inscriptions incorporated into the architecture of nine paintings. Although hardly unprecedented, they seem to be more specific here than in other Safavid manuscripts. Several are documentary epigraphs in prose referring to Sultan Ibrahim Mirza and Shah Tahmasp (folios 38b, 132a, and 162a). One inscription comes from the Koran (folio 147a), and another quotes a verse by the twelfth-century Persian poet Nizami (folio 188a). The rest are also poetic, but the verses are not derived from the *Haft awrang* or any other identifiable work of Persian literature. That they may have been composed especially for the Freer Jami is suggested by the close relation between the content of the verses and the subject of the paintings. The verse written on the back wall of *A Father*

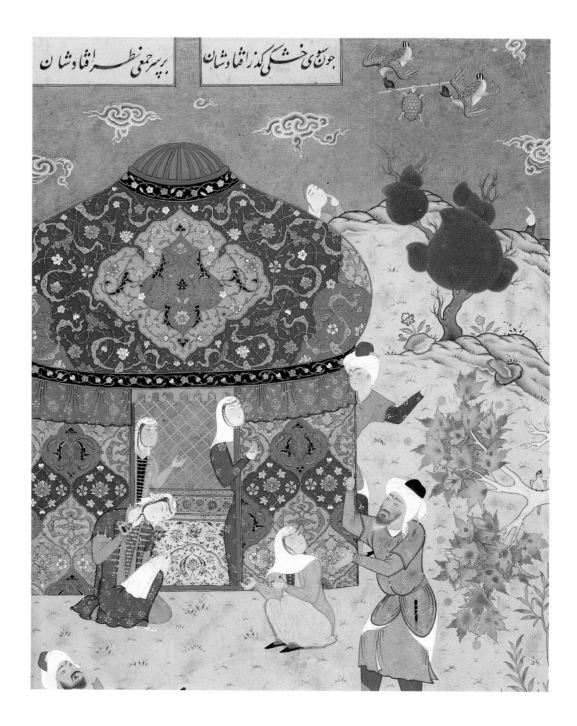

The Flight of the Tortoise (folio 215b, detail)

Advises His Son about Love (folio 52a), for instance, concerns a lover's heartache, while the poetic lines on the cornice of the building in *The Gnostic Has a Vision of Angels Carrying Trays of Light to the Poet Saʿdi* (folio 147a) address a paradisiacal theme. Perhaps even more direct and self-referential are the verses worked into the architecture in three of the *Yusuf and Zulaykha* illustrations, which refer metaphorically either to the buildings or to the *masnavi's* protagonists (folios 100b, 114b, and 120a).

From the variations in the appearance of the twenty-eight Freer Jami illustrations, we may surmise that its painters enjoyed considerable freedom in their work. With two exceptions, the compositions are diverse in layout, format, and decoration. The two exceptions are *The Wise Old Man Chides a Foolish Youth* (folio 10a), which is the first illustration in the manuscript as well as the first in the *Silsilat al-dhahab* poem, and *The Murid Kisses the Pir's Feet* (folio 207b), the initial painting in *Tuhfat al-ahrar*. These poems are among the first to have been transcribed for the manuscript and could have ready for illustration before other sections of the text. It is intriguing to consider the possibility that these two paintings—modest in size and unassuming in character—were executed early in the process of the manuscript's illustration and were judged as lacking the verve and creativity envisioned for the manuscript as a whole. In other words, these small and beautiful, but not particularly exciting, paintings may have been seen as the antithesis of the desired pictorial standard. Thus they inspired, by negative example, the creation of the twenty-six other remarkable scenes.

As we have seen, the artists who illustrated the Freer Jami were painting within the well-established, so-called classic style of the late fifteenth and sixteenth century. Similarly their approach to the illustration of the *Haft awrang* poems subscribed to several long-standing principles and practices in the history of Persian painting. First, artists in Iran never seem to have been concerned with the formation of fixed pictorial programs. Thus, while certain scenes recur regularly in illustrated copies of Jami's *masnavis*, there is no standard cycle—or even series of cycles—of *Haft awrang* illustrations any more than there seems to have been for the *Shahnama* (Book of kings) of Firdawsi or the *Khamsa* of Nizami. In short, within the recorded corpus of illustrated *Haft awrang* manuscripts,

illustrative variety and iconographic variation are the norm. Second, the relationship of works of Persian art to works of Persian literature tended to be very literal, and text illustrations were evidently conceived as faithful visual manifestations of literary expression, with artistic emphasis generally on tangible forms rather than abstract ideas. In both their choice and their treatment of scenes, the *Haft awrang* illustrators focused on the human actions and reactions through which Jami conveyed the mystical and moralizing themes that permeate his poetry. For *masnavis* without continuous narratives, such as *Silsilat al-dhahab*, *Tuhfat al-ahrar*, and *Subhat al-abrar*, artists selected scenes from among the many anecdotes and parables that Jami used both to link and to frame the poems' primary discourses. Whether creating large compositions that occupy a full page and incorporate a couple of *masnavi* verses or smaller ones enframed by many lines of poetry, they always related the subjects of their scenes, including the principal action and actors, clearly and directly to the nearest verses.

Within these traditions of Persian painting, the Freer Jami is a typical illustrated manuscript and more specifically a representative copy of the *Haft awrang*; its illustrative program includes both familiar and unique scenes that all depict concrete episodes in the poetic text and are all easily identifiable with reference to their nearest verses. In other respects, however, the volume is far more ambitious. With its original series of twenty-nine compositions (including one now missing from the *Layli and Majnun masnavi*), the Freer Jami is the most heavily illustrated copy of the *Haft awrang* known today. More significantly, while all its illustrations relate to the precise moment narrated in the incorporated verses, very few are restricted to the literal representation of Jami's text alone. The majority include additional, covert features not derived from the *Haft awrang* text that simultaneously expand and reinforce the literal or overt imagery in a variety of ways and respond to and parallel the metaphorical language and mystical messages of Jami's poems. In some cases, these extrapictorial elements can be inferred from the text, as in *The Pir Rejects the Ducks Brought as Presents by the Murid* (folio 153b), in which a royal disciple, or *murid*, brings a brace of ducks as a gift to a holy man. The principal characters in this anecdote to the *Subhat al-abrar* discourse on abstinence form the core for a number of other individuals—identifiable as members of the *murid's*

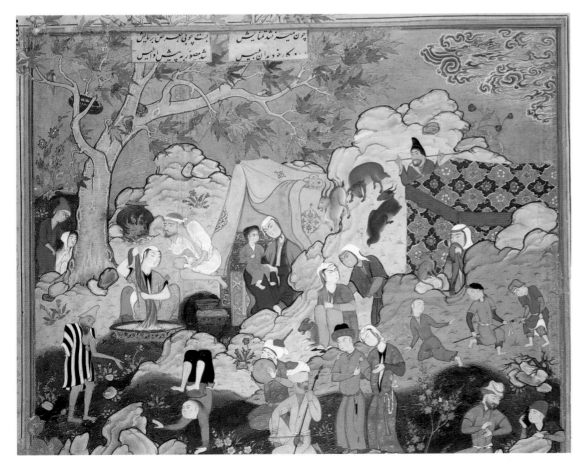

A Depraved Man Commits Bestiality and Is Berated by Satan (folio 30a, detail)

16

retinue—whose presence is not required by Jami's poem but who do make iconographic sense in terms of the disciple's status. Furthermore the grooms, falconers, and other retainers disposed within the composition's rocky landscape emphasize that a man so attached to attributes of worldly power and material possessions has much to learn before he can achieve abstinence, much less ever hope to attain salvation.

Even more intriguing are those illustrations that contain elements that could not be anticipated or even imagined from the text. This tendency is signaled at practically the very start of the Freer Jami in the *Silsilat al-dhahab* illustration *A Depraved Man Commits Bestiality and Is Berated by Satan* (folio 30a). Here the literal, overt imagery is confined to a small quadrant of the composition, while the rest of the scene is given over to what is probably a gypsy encampment. Some of the activities and denizens of this camp—such as the woman washing clothes, the mother and child at the tent entrance, the herder guarding his flocks, and the man spinning wool—were probably intended to contrast, by their very normality and domesticity, with the unnatural behavior taking place in the lower left. Other covert elements—including the boys playing hobbyhorse, the acrobats and musicians, and the figures in various stages of undress—echo the sodomite's sexual deviancy. And if by chance anyone were to miss the subject of the *Silsilat* narrative—and Jami's message that those who do not uphold the pillars of gnostic devotion are even more reprehensible than the devil—the artist of this painting has included another covert motif in the form of a gesturing man who directs the attention of both the spinner and the viewer toward the core (or perhaps in this case it might be "hardcore")

activity at the left. *Majnun Approaches the Camp of Layli's Caravan* (folio 253a) is completely dominated by covert features to the extent that the viewer is apt to spend far more time trying to decode the significance of such figures as the fainting or sleeping girl in the upper center than to contemplating Majnun's emotion as he comes upon the caravan encampment of his beloved.

Sometimes the covert imagery reinforces the *Haft awrang* text by the visual contrast and complement of singular details. Again, these motifs do not figure in the *masnavi* text, nor can they necessarily be inferred from it. The sleeping servant in *Yusuf Is Rescued from the Well* (folio 105a), for instance, is oblivious—as are all the other many figures in this caravan scene—to what is going on in the lower right where Yusuf is freed by the angel Gabriel. Similarly the act of greed and desecration that constitutes the overt imagery in *The Townsman Robs the Villager's Orchard* (folio 179b) is bracketed and contrasted by a pair of covert groups: the peaceful gathering of four youths in the garden above and the charitable gift at the doorway below.

The poetic inscriptions that are worked into the architectural setting of a half-dozen Freer Jami illustrations constitute another, equally significant type of covert imagery. In some cases these inscriptions respond to physical conditions or attributes explicit in the *Haft awrang* text, as in *The Aziz and Zulaykha Enter the Capital of Egypt and the Egyptians Come Out to Greet Them* (folio 100b), where the verse over the entrance to the city refers to the features of a beautiful young woman, as if deliberately repeating Jami's characterization of Zulaykha. Similarly in *Yusuf Preaches to Zulaykha's*

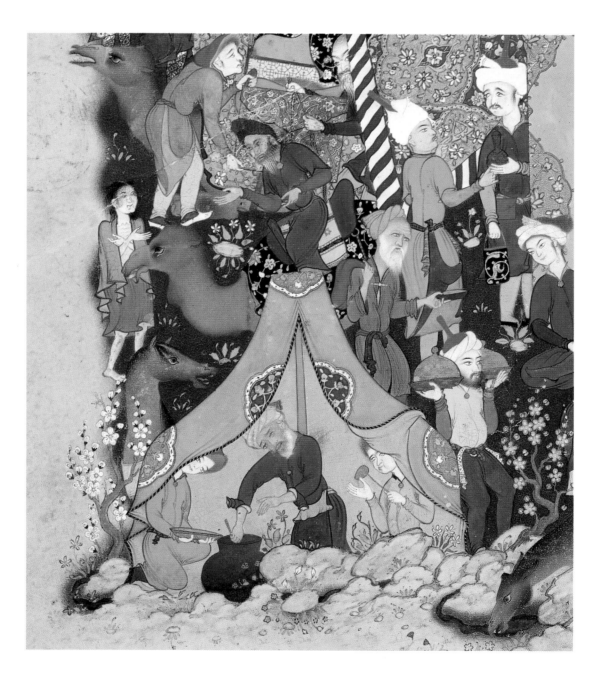

Majnun Approaches the Camp of Layli's Caravan (folio 253a, detail)

Maidens in Her Garden (folio 114b) the inscription combines references to the setting—which is both terrestrial and celestial—and to the message about God's mysterious purpose that Yusuf has been teaching Zulaykha's maidens.

The love poem being written on the back wall of *A Father Advises His Son about Love* (folio 52a) constitutes a more complex example of a text-image-text continuum. Indeed, in this illustration where the overt figures—the father and son—are not so immediately apparent, the covert features concentrated toward the back of the scene, including the chess-board and its players and the tortured poet and the painted "portrait" of his beloved, play a critical role in conveying Jami's message about the vagaries of human love and the complexities of divine love.

Some of the at once densest and subtlest blending of overt and covert imagery occurs in the *Silsilat al-dhahab* poem, which, as the first *masnavi* in the Freer Jami, sets the pictorial tone for the entire manuscript. It is also in *Silsilat* that Sultan Ibrahim Mirza is first identified as the volume's patron and where at least one motivation for his great commission is first indicated. It is doubtless not just a coincidence that the initial documentation of the manuscript's history appears in the *masnavi* whose very title—*Silsilat al-dhahab*, or Chain of Gold—evokes the dual concept of continuity and transmission that is so central to Iranian culture. In undertaking to support a *kitabkhana*, to employ court artists, and to order a deluxe volume of a classic work of Persian literature, Sultan Ibrahim Mirza was consciously continuing the artistic patronage of the Safavid dynasty as practiced by his grandfather, father, and uncles. Of this distinguished lineage of Safavid patrons, the prince paid most conspicuous homage to Tahmasp—his uncle and father-in-law, mentor and monarch—by having a laudatory inscription to the shah written above his own *kitabkhana* "tag" in the third *Silsilat* illustration (folio 38b) and reiterated a little more than halfway through the manuscript (folio 162a). At the same time Sultan Ibrahim Mirza deviated from previous family patronage as exemplified by Tahmasp in choosing the *Haft awrang* by Abdul-Rahman Jami as the literary vehicle for a major artistic commission. Whereas Tahmasp's *kitabkhana* (directly carrying on from that of Isma'il I) produced volumes of works by long-venerable poets like Firdawsi and Nizami, the prince had his *kitabkhana* create the first illustrated Safavid copy of a

relatively new literary classic by a mystical author whose ideas and beliefs were suspect within certain quarters of the Safavid dynasty. Thus, while Sultan Ibrahim Mirza clearly wanted to emulate and honor older members of his family, he also sought to challenge, rival, and perhaps even surpass the patronage of other family members by daring to commission a very different (and more contemporary) type of literary masterpiece.

The timing of the prince's commission is equally significant. In 1555–56 Shah Tahmasp promulgated an edict banning the arts that culminated a long period of personal disengagement from the arts and other pleasures. One consequence of the shah's gradual withdrawal from active artistic patronage is that many of the artists previously employed at the royal *kitabkhana* were free to work for other patrons. Circumstances were certainly propitious for Sultan Ibrahim Mirza to pick up, as it were, where Tahmasp had left off, and the prince may have been enabled or emboldened to set up the kind of *kitabkhana* workshop necessary for the production of a deluxe manuscript precisely because of the availability of leading artists whose services were no longer required at his uncle's court. It certainly can be no accident that during the late summer and fall of 1556 three court artists—Malik al-Daylami (who had been assigned by Tahmasp to his nephew's *kitabkhana*), Rustam-Ali, and Shah-Mahmud al-Nishapuri—completed key sections of the prince's *Haft awrang*. Also by the fall of 1556 Sultan Ibrahim Mirza had taken up residence in Mashhad as governor and doubtless had begun to contemplate the eventuality of marriage to his cousin, the shah's daughter, Gawhar-Sultan Khanim. What better way for the prince to celebrate his "coming of age" than with the commission of an illustrated manuscript, one whose quality would complement previous Safavid patronage and whose originality, both as a work of literature and a work of art, would proclaim his independence within that family tradition.

The notion of coming of age forms part of a broader construct of the human life cycle or the ages of man. The pictorial program of the Freer Jami expresses key stages in that life cycle, including both its temporal and spiritual dimensions. The manuscript's illustration is informed by and interwoven with pervasive *Haft awrang* themes—the mystery and power of love; the conflict between good and evil, reality and illusion; and death as the ultimate form of release—that are integral to Jami's poetic and

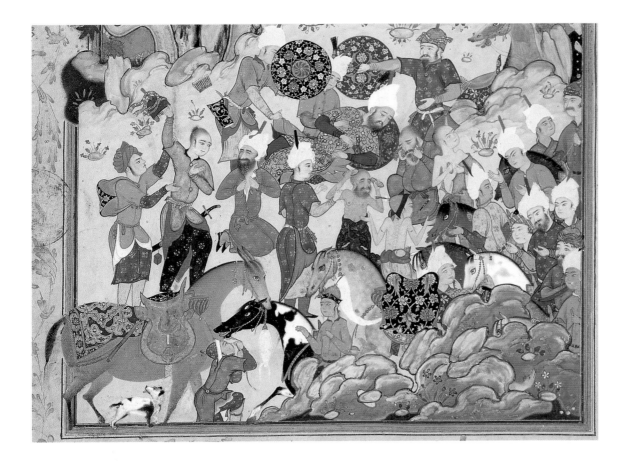

Iskandar Suffers a Nosebleed and Is Laid Down to Rest (folio 298a, detail)

mystical leitmotif of the search for enlightenment and fulfillment through knowledge of the divine. The progression toward this goal begins in the first illustration, where a callow youth learns a key lesson about the direction he should pursue from a spiritual guide (folio 10a), and ends in the final composition with the impending death of Iskandar, a valiant explorer of the mysteries of life and ardent seeker of truth (folio 298a). Between initiation into the path of true belief and release to union with God come many other defining moments of human existence. These include the formation and affirmation of essential relationships critical to one's course through life (folios 153b and 207b), the trauma of self-doubt (folios 147a and 221b), and the recognition or assertion of self-worth (folios 169b and 291a). Maturation through these stages brings the ability to accept responsibility and to distinguish between right and wrong (folios 52a and 188a). The unwillingness to mature, to take decisive action, or to accept a fundamental verity has adverse and sometimes even fatal consequences (folios 38b, 162a, 179b, 194b, and 215b). Thus moments of weakness and failure (folio 30a) are balanced by those of triumph and apotheosis (folios 105a and 275a). Throughout life there is the bliss and torment of passion that begins with physical attraction (folios 59a, 100b, and 231a), passes through various trials and tribulations (folios 110b, 114b, 120a, and 253a), and ends either in tragedy or sanctity—or both (folios 64b, 132a, and 264a).

IT WOULD BE pushing the case too far to equate the life cycle as illustrated in the Freer Jami with the life history of Sultan Ibrahim Mirza. Yet given the young prince's poetic and artistic interests, it is entirely plausible that he deliberately sought to intensify the message of Jami's poetry—and perhaps even to personalize it—through the medium of painting. Certainly various biographical details—such as the prince's authorship of mystical poetry, his gubernatorial appointments, and the events leading up to and surrounding his marriage—seem to be reflected in the choice and interpretation of a number of *Haft awrang* scenes.

Sultan Ibrahim Mirza may have selected the *Haft awrang* for illustration because of its message about life, and he may have inspired or instructed his *kitabkhana* artists to create compositions that would embody his reading of that message. The history of Persian manuscript illustration contains other notable examples of the integration—and even manipulation— of text and image for both illustrative and interpretive ends. The *Haft awrang* made for Sultan Ibrahim Mirza both sets a new standard in this strategy and stands as a magnificent marker of a cultural tradition in which patronage of the literary and visual arts was a virtual imperative of princely life.

Notes

1. Österreichische Nationalbibliothek, Vienna (Mixt. 1480), see Dorothea Duda, *Die illuminierten Handschriften der österreichischen Nationalbibliothek: Islamische Handschriften, I: Persische Handschriften* (Vienna: Verlage der österreichischen Akademie der Wissenschaften, 1983), 1:210–11, 2: pls. 30–31.

2. General Egyptian Book Organization, Cairo (Adab Farsi 908), see Thomas W. Lentz and Glenn D. Lowry, *Timur and the Princely Vision: Persian Art and Culture in the Fifteenth Century* (Los Angeles: Los Angeles County Museum of Art; Washington, D.C.: Arthur M. Sackler Gallery, 1989), color reproduction p. 294.

3. Qazi Ahmad, *Calligraphers and Painters: A Treatise by Qadi Ahmad, Son of Mir Munshi (circa A.H. 1015/A.D. 1606)*, trans. V. Minorsky (Washington, D.C.: Freer Gallery of Art, 1959), p. 159; Qazi Ahmad, *Gulistan-i hunar* (Garden of the arts), ed. Ahmad Suhayli-Khunsari, 2d ed. (Tehran: Kitabkhana Manuchihri, n.d.), p. 114.

4. Gulistan Library, Tehran (MS 2183), see Badri Atabay, *Fihrist-i muraqqa'at kitabkhana-i saltanati Tehran* (Catalogue of the albums of the Imperial Library, Tehran) (Tehran: Chapkhana-yi Ziba, 1978–79), pp. 337–40; Collection of Prince Sadruddin Aga Khan, Geneva (MS 33), see Anthony Welch and Stuart Cary Welch, *Arts of the Islamic Book: The Collection of Prince Sadruddin Aga Khan* (Ithaca, N.Y.: Cornell University Press for the Asia Society, 1982), cat. no. 30.

5. Qazi Ahmad, *Calligraphers and Painters*, pp. 183, 160; Qazi Ahmad, *Gulistan-i hunar*, pp. 143, 115.

6. Qazi Ahmad, *Calligraphers and Painters*, p. 155; Qazi Ahmad, *Gulistan-i hunar*, pp. 106–7.

7. British Library, London (Or. 2265), see Stuart Cary Welch, *Persian Painting: Five Royal Safavid Manuscripts of the Sixteenth Century* (New York, 1976), 19–33, colorplates.

8. Qazi Ahmad, *Khulasat al-tawarikh* (Abstract of history), ed. Ihsan Ishraqi (Tehran: Intisharat-i danishgah-i Tehran, 1980), 2:640–41.

9. Afushta'i Natanzi, *Naqavat al-athar* (Selections of history), ed. Ihsan Ishraqi (Tehran: Bunga-yi tarjuma-yi nashri kitab, 1950), p. 47.

10. Qazi Ahmad, *Calligraphers and Painters*, p. 158; Qazi Ahmad, *Gulistan-i hunar*, p. 110.

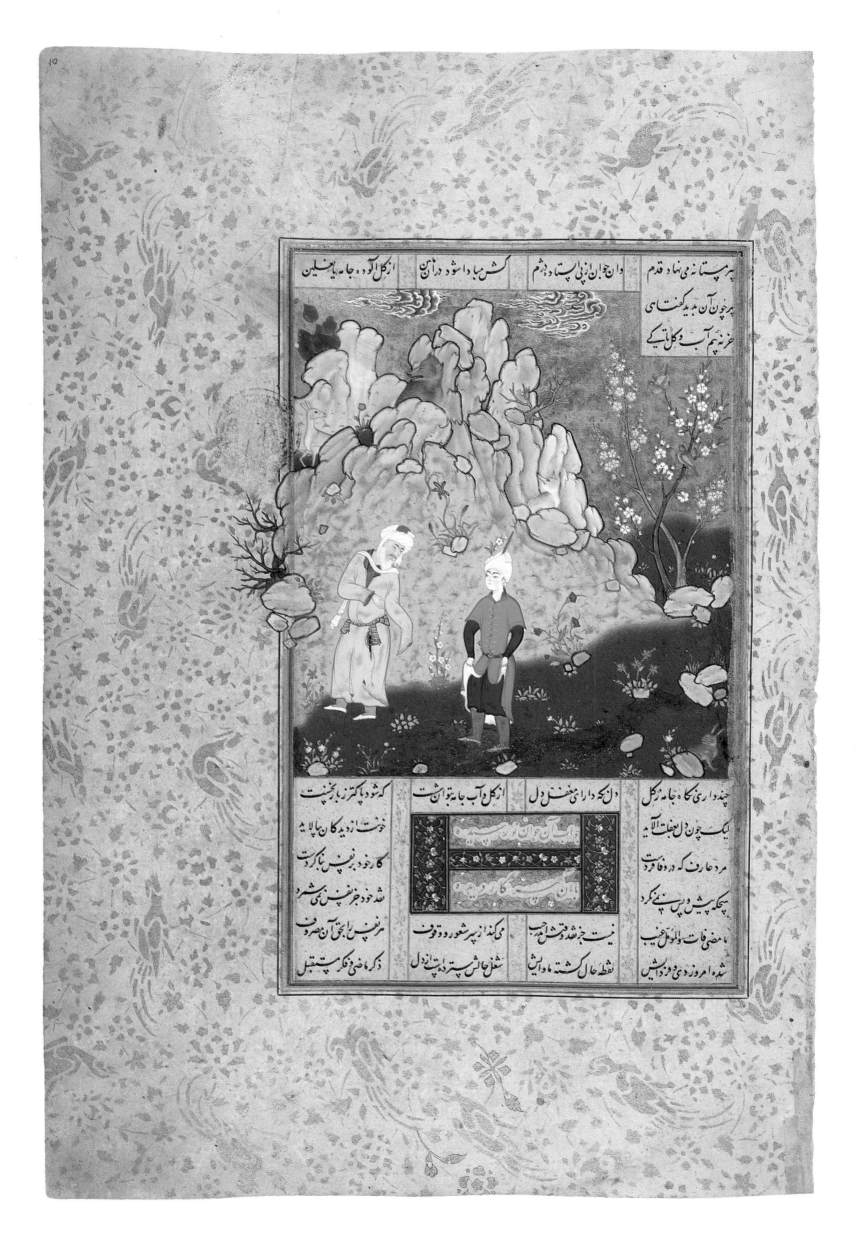

Folio 10a

THE WISE OLD MAN CHIDES A FOOLISH YOUTH
14.6 x 13 cm

The first composition in the Freer Jami, illustrating a passage in *Silsilat al-dhahab* (Chain of gold) about spiritual enlightenment, is a modest introduction to the manuscript's otherwise complex pictorial program. A Sufi *pir*, or master, and his young disciple are traveling together along a road when it suddenly turns to mud. The master continues walking, but the youth stops, afraid of soiling his clothes and shoes. The old man then chastises his disciple, reminding him that it is far more important to keep his heart pure than his clothes clean.

Although the illustration faithfully depicts the scene as narrated in the *Silsilat al-dhahab* text, the *pir* and novice pass through a stream rather than the muddy road specified by Jami. Brown stains, presumably mud, cover the old man's tan robe. The young disciple lifts his orange outer robe to avoid the water lapping over his left shoe. The craggy background contains its own little drama, with a fox gazing up at a bear who looks down at a deer who in turn peers back across the hill at a fox lurking behind a rock in the lower-right foreground. A series of paired natural features, including racing clouds and entwined trees and birds, seems to mirror the human protagonists alongside the stream below and hint at the complex interactions characteristic of the Freer Jami's subsequent illustrations.

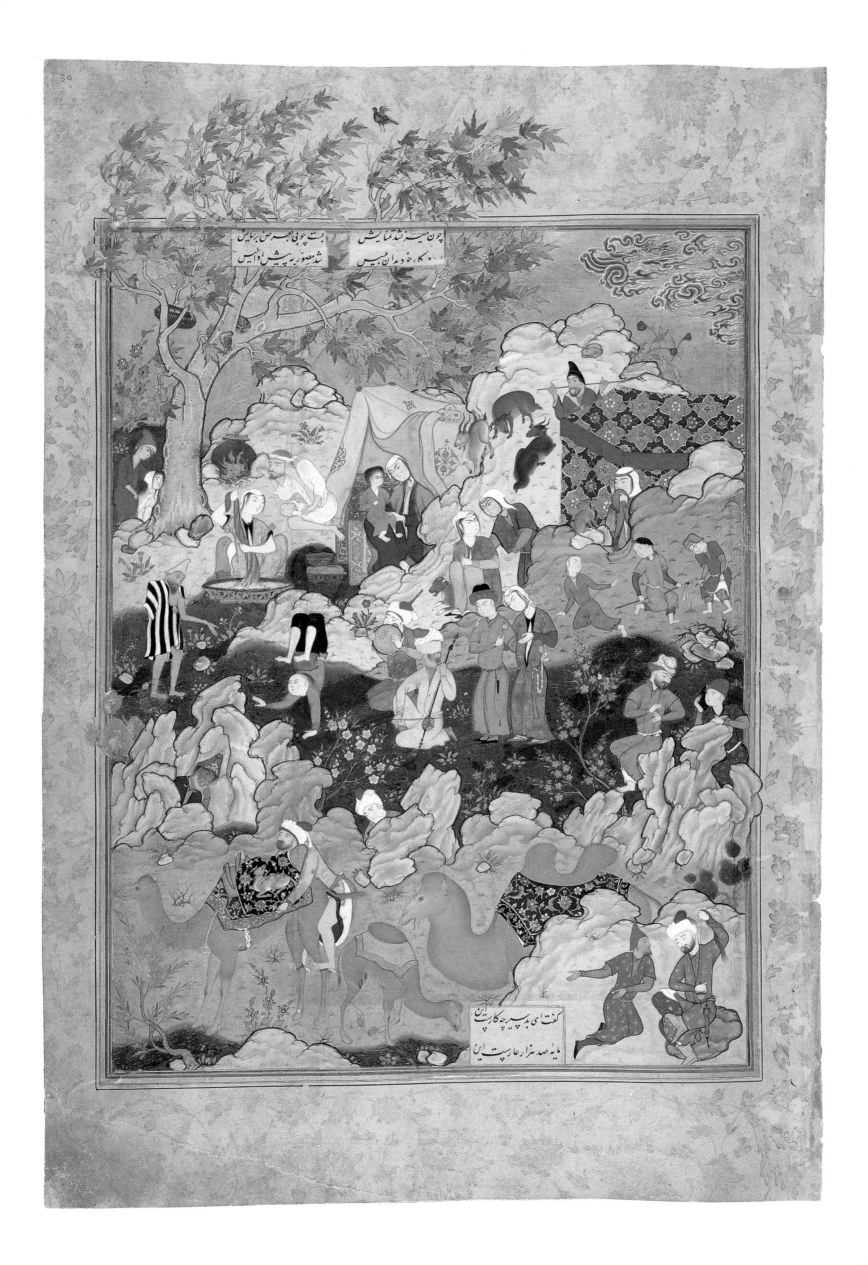

Folio 30a

A DEPRAVED MAN COMMITS BESTIALITY
AND IS BERATED BY SATAN
25 x 19 cm

This marvelous illustration falls in a section of *Silsilat al-dhahab* that concerns prolonged silence as a manifestation of devotion to God. Whoever does not speak and listen only to God is corrupt and acts and talks as Satan's deputy, even outdoing and astonishing the devil himself. The theme is reinforced by an anecdote about a man in the desert who is overcome by lust and mounts a female camel. While the man is thus occupied, Satan appears and begins to curse him for his act. "Before people reproach you," rails the devil, "they will blame me, and that would be giving me a bad name. By God, such a trick has never entered my heart, and such vileness has never come to my mind."

The "vile trick" takes place in the lower-left corner of the composition, where the desperate man—actually looking more pained than lustful—has hitched up his clothes and mounted the camel from two wooden supports tied to the animal's hind legs. A large Bactrian camel, who may be the she-camel's mate, stares indignantly from the right, while a young camel, perhaps an offspring, grazes peacefully alongside. Dark-faced, white-bearded, and wearing an embroidered cap, Satan peers from a rocky outcropping just above the mounted camel. He holds a finger to his mouth in a gesture of emotion—in this case astonishment—typical of classical Persian painting.

A lively encampment, featuring various domestic activities, dominates the middle and upper areas of the illustration. Its denizens, including musicians and acrobats, may be gypsies—peripatetic peoples long regarded in Iran and elsewhere as having loose morals and being synonymous with shamelessness. The combination of two seemingly unrelated scenes—bestiality below and gypsy encampment above—and juxtaposition of ordinary folk, such as the washerwoman, with entertainers, may constitute a twofold pictorial reproach against an individual malefactor and a group of social outcasts.

Folio 38b

THE SIMPLE PEASANT ENTREATS THE SALESMAN
NOT TO SELL HIS WONDERFUL DONKEY
26.3 x 14.5 cm

Inscribed over doorway:

By order of the kitabkhana of Abu 'l-Fath Sultan Ibrahim Mirza

Inscribed at top of building:

Oh God, strengthen the rule of the just Sultan Abu 'l-Muzaffar Shah Tahmasp al-Husayni.
May God perpetuate his reign beyond the separation of the two worlds [death].

This is one of two illustrations in the Freer Jami with an inscription that extols the Safavid monarch Tahmasp and another that announces Sultan Ibrahim Mirza as the manuscript's patron. As in *The Fickle Old Lover Is Knocked off the Rooftop* (folio 162a), the placement of these epigraphs mirrors the dynastic relationship between the Safavid king and his princely nephew. Here they may also refer subtly to the surrounding Jami verses that caution us against believing in flatterers—a message that is conveyed through the story of a naive peasant who put his old donkey up for sale at market, only to taken in by the salesman's pitch about the pathetic creature's strength and energy.

The illustration captures the hustle and bustle of a city marketplace filled with salesmen, customers, horsemen, and even a herdsman and goats. The tiled facade in the background undoubt-edly represents a bazaar, center of the town's commercial activity. That this building may function under royal patronage is suggested both by the inscription proclaiming Shah Tahmasp and by the heraldic device in the form of a shield, bow, and quiver hanging just inside the arched entryway. More human interest is provided at the bazaar's right side, where a bearded shopkeeper sits on a raised platform in front of shelves laden with loaves of bread. He uses gold and silver weights to measure out flour from a cloth sack for a stout, matronly shopper. Hanging onto the old woman's sash is a young boy, perhaps a grandchild, who looks down in trepidation at a yapping dog.

The composition also abounds in pictorial contrasts that reinforce Jami's point about the venality of the donkey seller and the naiveté of the peasant. Most striking is the difference between the emaci-ated donkey stumbling in the middle of the marketplace and the elegant dappled horse and rider prancing along in the same direction.

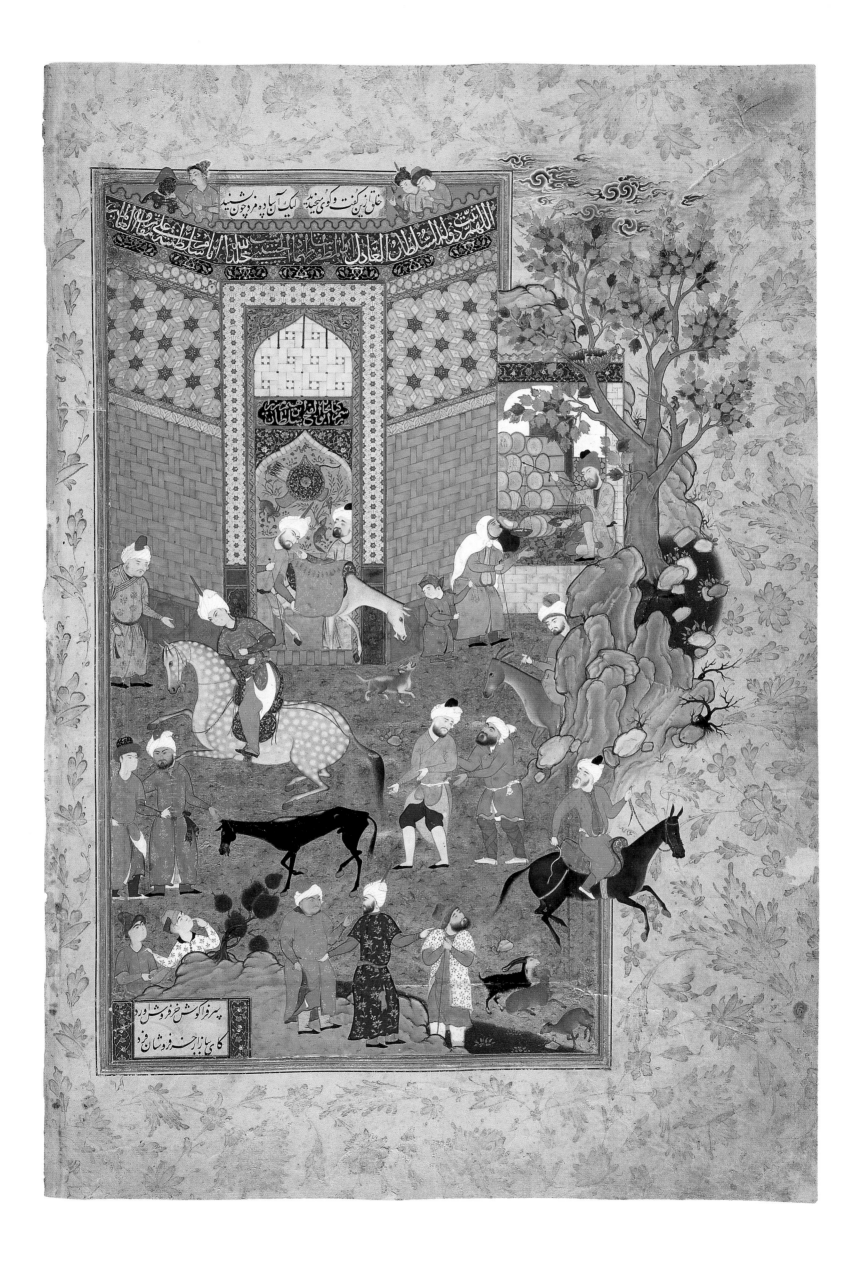

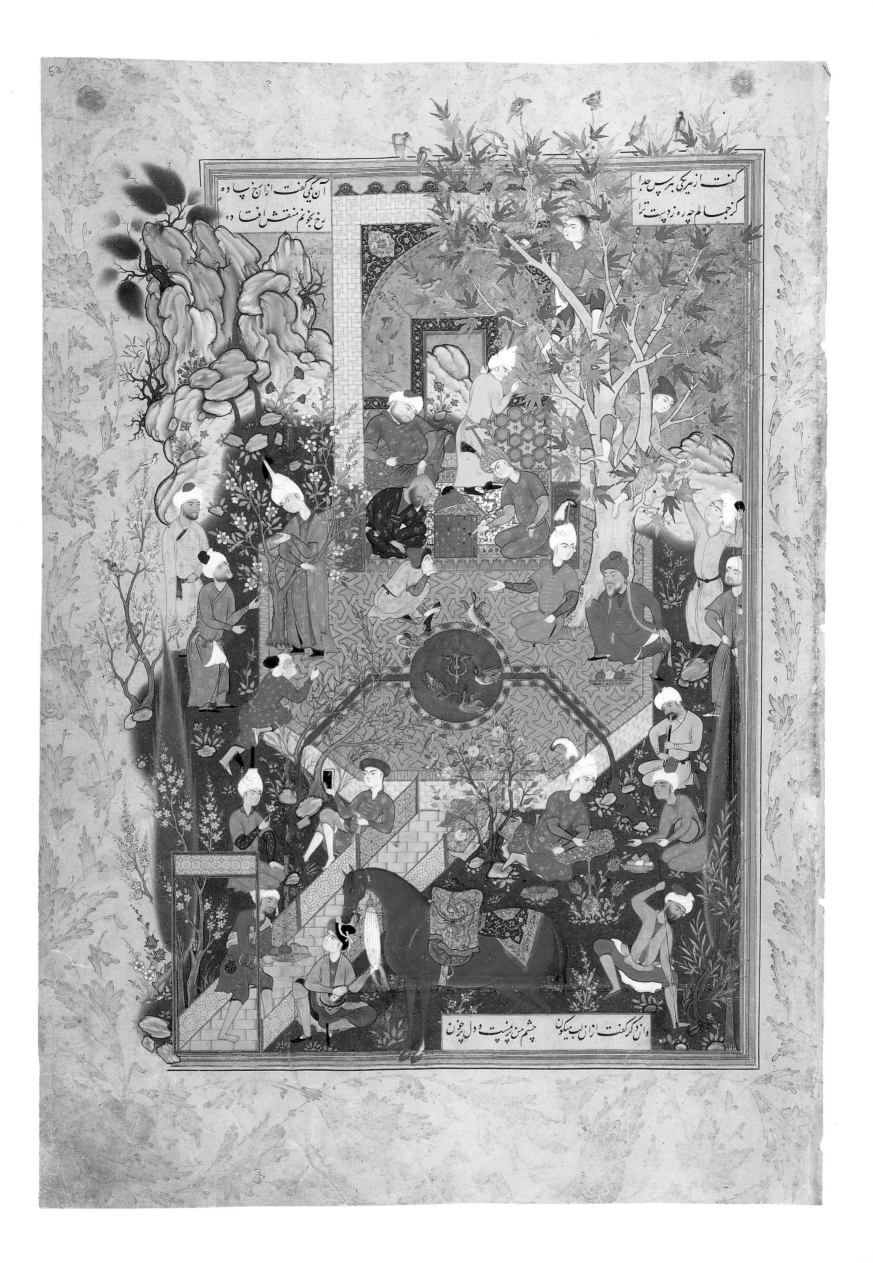

Folio 52a

A FATHER ADVISES HIS SON ABOUT LOVE

26.3 x 16.8 cm

Inscribed on back wall:

I have written on the door and wall of every house about the grief of my love for you.
That perhaps you might pass by one day and read the explanation of my condition.

In my heart I had his face before me.
With this face before me I saw that which I had in my heart.

May your grief ...

A lovely youth asks his father how to choose from among the many suitors courting his favor and praising his appearance. The paternal advice is to ignore protestations of affection for physical beauty and to respond only to the admirer who has passed beyond infatuation with external attributes to the true love of inner qualities. The wise father concludes his discourse with the explanation that, although divine love is eternal and faultless, every person sees beauty with different eyes.

This discussion on the essence of love takes place in a beautiful garden bower and pavilion, a characteristic setting for lovers in Persian literature and art. Although the identification of father and son is not immediately apparent, they are most likely the two figures seated beneath the tree on the right side of the raised, octagonal terrace—the gray-bearded father in a brown robe and the son in orange gesturing toward the center of the scene.

The moral and message of this *Silsilat al-dhahab* text are forcefully conveyed by the activities taking place under the pavilion archway. There two men are intently engaged in a game of chess, a traditional metaphor both for life and for the relations between lover and beloved. The prominent position of the chess game and the difference in age and demeanor between the two players are clear visual allusions—first to the subject of the interchange between father and son and then to the distinction between physical qualities and spiritual essence.

An even more pointed and poignant commentary on the meaning of Jami's verses appears on the back wall of the pavilion, where a young man pens a poem about the pain of love he feels for his beloved. His verses both enframe and address a standing painted figure, who must represent the beloved.

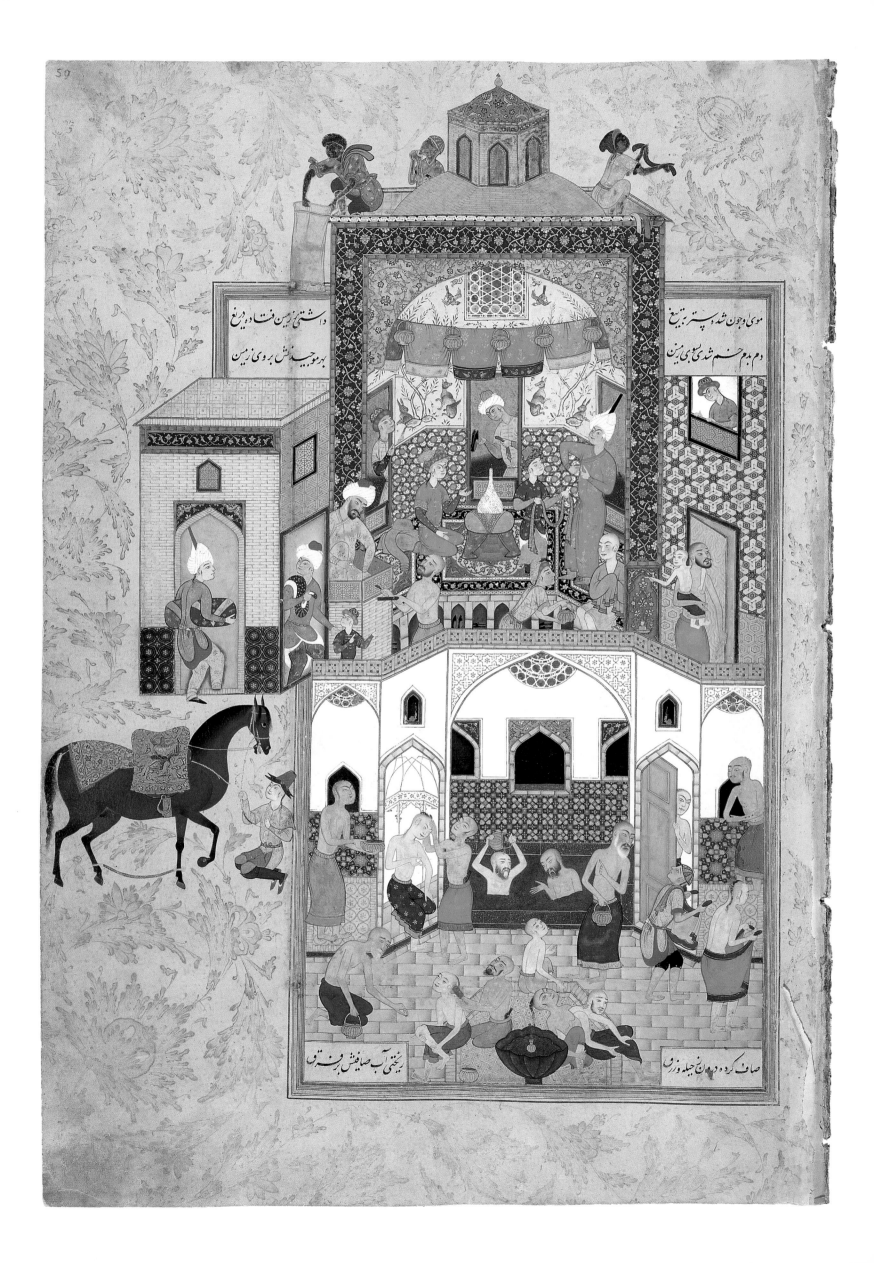

Folio 59a

THE DERVISH PICKS UP HIS BELOVED'S HAIR
FROM THE HAMMAM FLOOR

30.1 x 19 cm

This lively *hammam*, or bathhouse, sets the stage for a long and complicated *Haft awrang* poem about sin and repentance involving an old Sufi mendicant, or dervish, who tries to court a beautiful youth. The young man is having his head shaved, and the dervish collects every strand of hair as it falls to the ground. Despite this and other stratagems, the youth refuses to pay any attention to the old man, causing him to die grief-stricken. Later shaken by an apparition of the deceased, the young man himself becomes a mendicant and passes the rest of his days striving for divine love through acts of atonement for the dervish's death.

The painting relates to the beginning of the story when the dervish tries to win the affections of the beautiful youth in the *hammam*. As an illustration it seems to have much less to do with the actions and reactions of the lover (the dervish) and beloved (the young man) than with the bathhouse where Jami sets the first part of his moralizing tale.

The bathhouse is an elaborate, multichambered structure depicted in sectional elevation with one room stacked above the other and a side entrance projecting into the left-hand margin. A turbaned youth, apparently having just dismounted from the richly caparisoned horse below, enters the *hammam* behind a young man and a little boy who have already passed through the entry portal and into the changing room. This space is hung with colorful towels and metal buckets used in bathing and occupied by *hammam* attendants and patrons in various stages of undress. A bearded man carrying a child, both wrapped below the waist in long towels, leaves the changing room through a door at the right, presumably heading for the bathing areas depicted below.

The bath chamber dominates the lower part of the composition and includes about a dozen bathers clad only in towels. Attendants are scrubbing and massaging young clients around an octagonal pool in the foreground, while a pair of middle-aged bathers, immersed up to their chests, soak in a rectangular tank at the rear. Toward the left side an elderly white-bearded man stoops down to pick up something quite small from the green-tiled floor. This aging figure may be the dervish of Jami's tale, collecting the hairs of his beloved, who may be the young man above having his head shaved.

Folio 64b

BANDITS ATTACK THE CARAVAN OF AYNIE AND RIA
27.9 x 18.2 cm

The *Silsilat al-dhahab* poem contains a long love story about a young groom named Aynie and his bride Ria who set off with a caravan to visit Medina, the Muslim holy city in the Arabian peninsula. While only ten kilometers from Medina, the newlyweds are set upon by armed marauders. Aynie fights bravely and kills virtually the entire band of brigands until he is felled by one of the few remaining bandits. When Ria sees her husband's lifeless body drenched in blood, she laments at great length, then places her face on his and dies. The couple's friends shroud them in silk and bury them in a single grave, to be united forever. Eventually a tree grows on the burial spot, its limbs streaked in yellow and red representing the paleness of the couple's faces and their tears of blood.

This tragic tale belongs to a series illustrating the stages of love, which also includes the anecdote about the dervish wooing the beautiful youth in the *hammam* (folio 59a). Aynie and Ria die for love of each other: the young husband dies protecting his bride, who in turn expires because she cannot live without her husband. These pure souls—their love cut off in full flower—are then joined in eternal union and spiritual resurrection.

The illustration depicts the moment when Aynie, mounted on a camel and holding a long spear, seems to have succeeded in routing the attackers, while Ria, also on camelback, looks on from the far right. Most of the bandits have been slain (two by decapitation), and others flee on horseback or on foot. Another mounted attacker, brandishing a sword, attacks from above; his may be the fatal blow.

On the whole this is a standardized battle scene with a few specific elements, such as Ria and Aynie on camelback, that relate it to the *Haft awrang* text. Yet the composition also contains several significant details. The two fantastic creatures confronting each other on Aynie's saddle blanket seem to parallel the duel between good and evil taking place on the battlefield. Far more original and intriguing is the pair of figures entering the scene from the right: a stooped blind man carrying a bronze begging bowl is being guided through the mayhem by a young man equipped with a staff and flask. The blind beggar may refer to Ria's lament that the sun went into decline upon Aynie's death, or he may allude more generally to Jami's discussion of how, after the lover has come to know darkness, he turns his face from himself and toward the beloved.

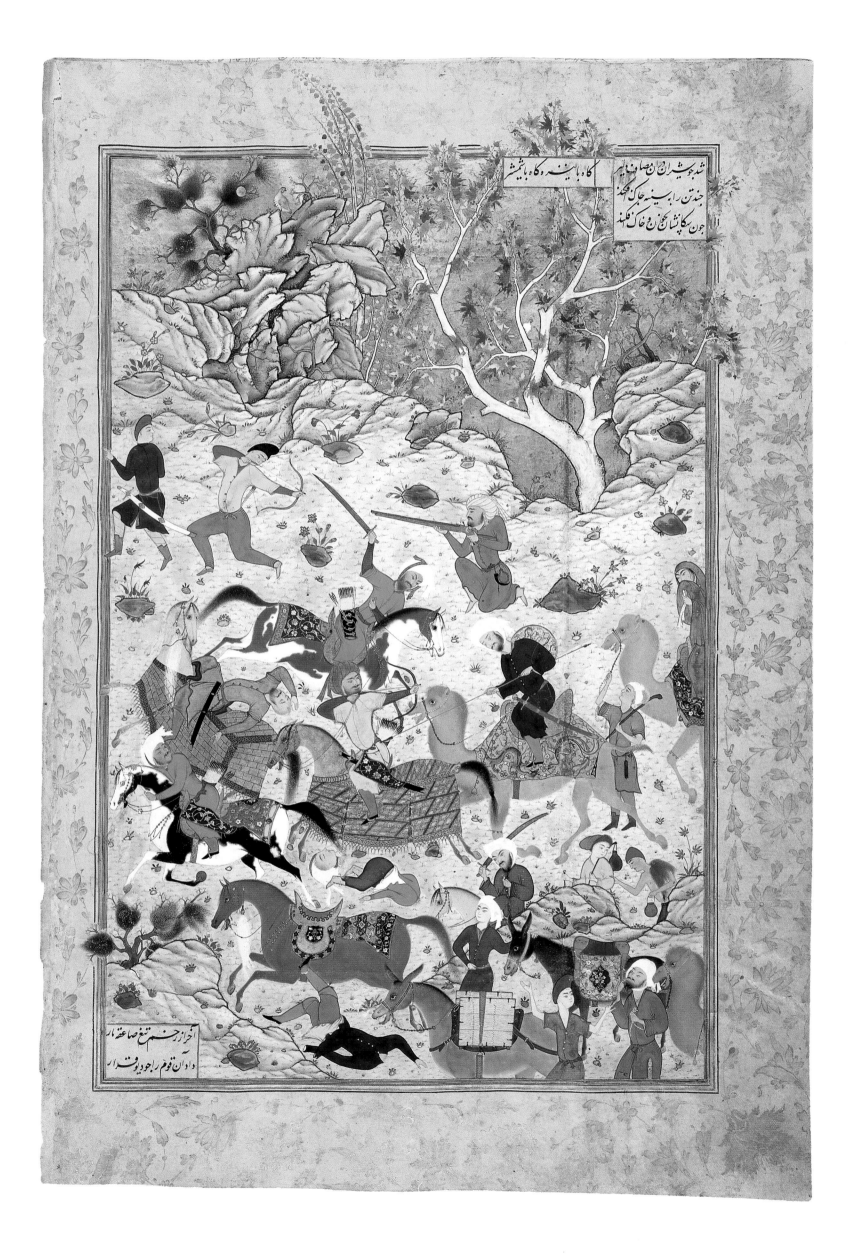

Folio 100b

THE AZIZ AND ZULAYKHA ENTER THE CAPITAL OF EGYPT
AND THE EGYPTIANS COME OUT TO GREET THEM

29.1 x 19.5 cm

Inscribed over city entrance:

> *The black pupil of your eye is an ambergris-scented beauty mark on the face of time,*
> *[You are] the glory of paradise and the envy of the picture gallery of China.*

The romance of Yusuf and Zulaykha is universally regarded as the masterpiece of the *Haft awrang*. The long and complicated *masnavi* opens with an evocative discourse on absolute beauty and the power of love and progresses through a dense plot and multiple subplots narrating the lives of Yusuf and Zulaykha (characters more familiar in traditions outside the Near East as Joseph and Potiphar's wife) and particularly Zulaykha's enduring passion for Yusuf. Her infatuation begins with a series of dreams of a radiant male youth of superhuman beauty and grace. Later she comes to believe that the man of her dreams is the *aziz* (minister) of Egypt (Misr) and is overjoyed when her father arranges her marriage to the *aziz* and sends her off to Egypt escorted by a magnificent caravan. Too late she realizes, in despair, that the *aziz* is not her beloved.

This illustration depicts the moment when Zulaykha, riding in a camel-borne litter and followed by both female and male attendants, reaches the gates of the Egyptian capital, where the *aziz* has come to meet her. Mounted on a white horse, the groom approaches his bride and turns backward to take a golden platter from an attendant, initiating the traditional Iranian custom of showering the bridal party with gold, silver, pearls, and jewelry. Musicians play a variety of instruments, and two boys with castanets dance for Zulaykha. Zulaykha is further welcomed by the Egyptians crowding the city's walls, domes, and minaret and heralded by additional musicians pounding kettledrums and sounding clarions.

Teeming with more than one hundred people, this expansive composition vibrantly represents the principal actors and action of Jami's poem. At the same time its myriad figures and urban setting accord with an account of Sultan Ibrahim Mirza's welcome of his bride, Gawhar-Sultan Khanim, outside the city gate of Mashhad in the spring of 1560. It is possible that the description of Gawhar-Sultan Khanim's wedding party and the depiction of Zulaykha's are rooted in a common topos for such celebrations. In any event the art and life of Sultan Ibrahim Mirza appear to come together in this marvelous painting—just as the princely patron may have intended.

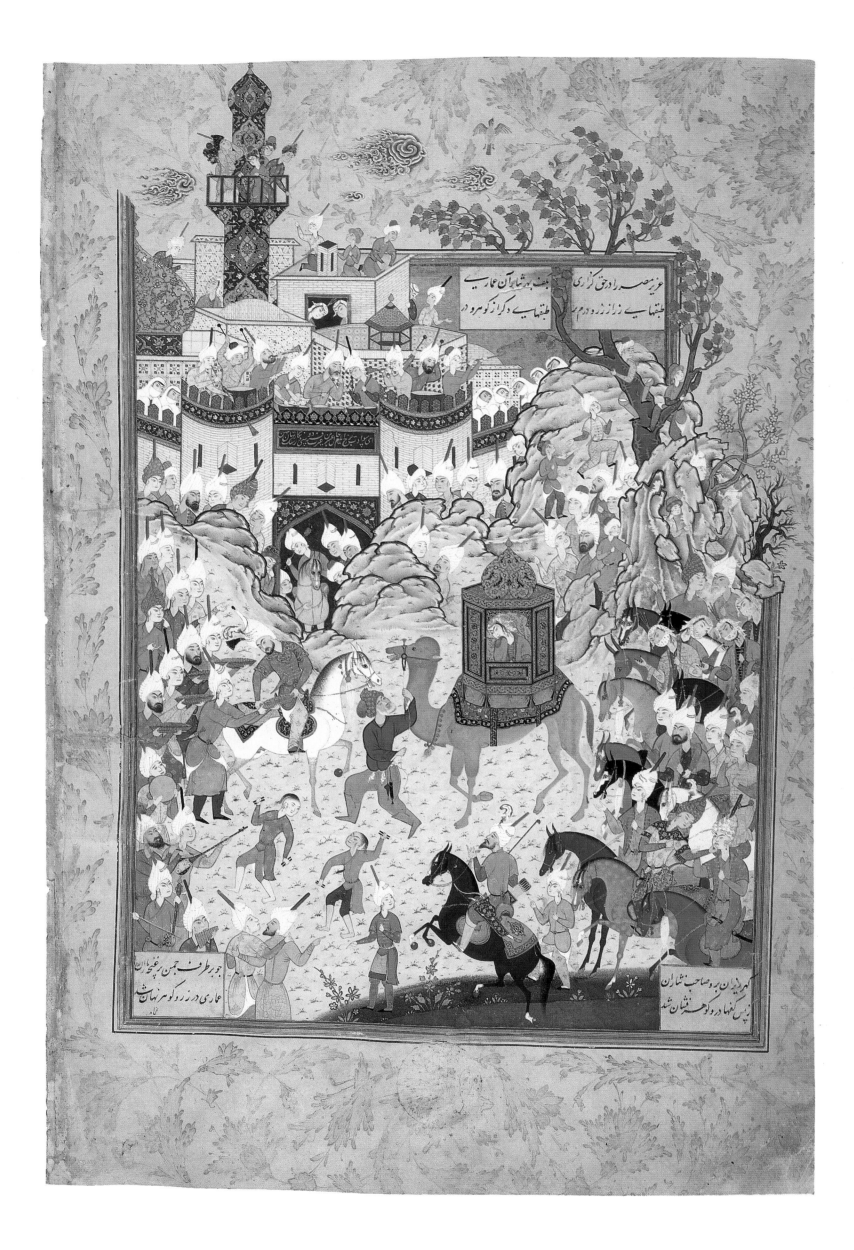

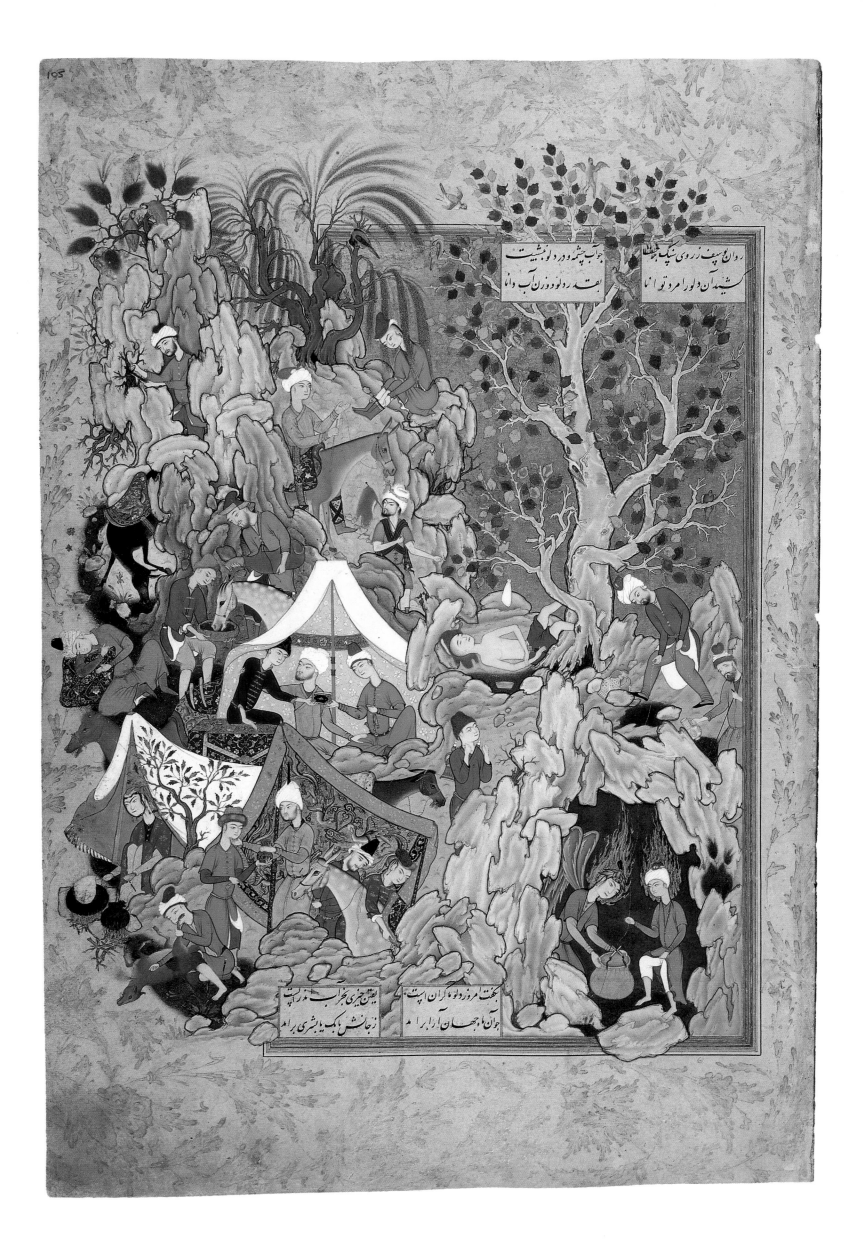

Folio 105a

YUSUF IS RESCUED FROM THE WELL

24 x 20.8 cm

Yusuf and Zulaykha is the most frequently illustrated of Jami's seven *masnavis*, and this scene of the well-known episode in the life of the Prophet Yusuf was a particular favorite in sixteenth-century Iran. As recounted in the Bible, the Koran, and a variety of Persian poems including the *Haft awrang*, Yusuf was thrown into a well by his jealous brothers. In Jami's version of the tale, Yusuf is joined in the well by the angel Gabriel. After three days a caravan en route to Egypt camps beside the well. The first person to draw water from the well is a man named Malik. When the bucket appears, Gabriel tells Yusuf to stand in it, "and when you rise above the rim of the well, you will once more fill the sky with light."

Much of the composition is devoted to the caravan encampment, pitched in a rocky landscape that spills out into the left margin. Some caravanners are cooking and looking after animals, while others rest and attend to their own comforts. Of particular note is what looks like a literary discussion taking place in the middle tent. The right side of the illustration is dominated above by a large plane tree full of birds and below by the well into which Yusuf was cast by his jealous brothers. The well is rendered in cross section as an irregular cave. Within its depths are Gabriel and Yusuf, both nimbed in flames. The winged angel holds the bucket as Yusuf prepares to step into it from the boulder on which he has been perched throughout his ordeal. Bracing his foot against a rock for leverage, the unwitting rescuer Malik has just begun to draw up his bucket and is about to exclaim: "What a lucky fate is this, which sends such a shining moon from the depths of a dark well."

Folio 110b

YUSUF TENDS HIS FLOCKS

20.5 x 16.4 cm

After his rescue from the well, Yusuf is taken to Egypt, where he is sold at a slave market and enters the service of the *aziz* of Egypt. There Zulaykha finally encounters the man of her dreams and embarks on a series of futile efforts to win his love. Learning that Yusuf is set on becoming a herds-man, since only those who tend flocks are fit to be prophets and leaders of nations, Zulaykha gathers a group of special lambs with silken fleece and heavy tails. Yusuf then goes off to the plains to tend these flocks accompanied by Zulaykha, who devotes herself to watching over him.

This episode in the *Yusuf and Zulaykha* narrative immediately precedes Zulaykha's declaration of love for Yusuf and the start of conflict in their relationship. Its point, as articulated by Jami at the outset, is that a lover who can shed all personal desires, as Zulaykha can do for the moment, becomes totally immersed in the will of the beloved.

This charming painting is among the smallest in the Freer Jami manuscript. Faithful to the text in its representation of Yusuf as herdsman and would-be prophet and Zulaykha as guardian and would-be lover, the illustration also contains certain features that reinforce the themes of caretaking, nurturing, and selfless love. Most obvious are the mother-and-child pairings, one human and the other equine. The attentive goat at Yusuf's feet seems to parallel Zulaykha in the tent above. The seemingly antagonistic scene in the foreground may refer to the imminent tension in the *Yusuf and Zulaykha* story. The aggressive scenes of animal combat in the surrounding margins also appear to foreshadow the conflict about to develop in this *Haft awrang* narrative.

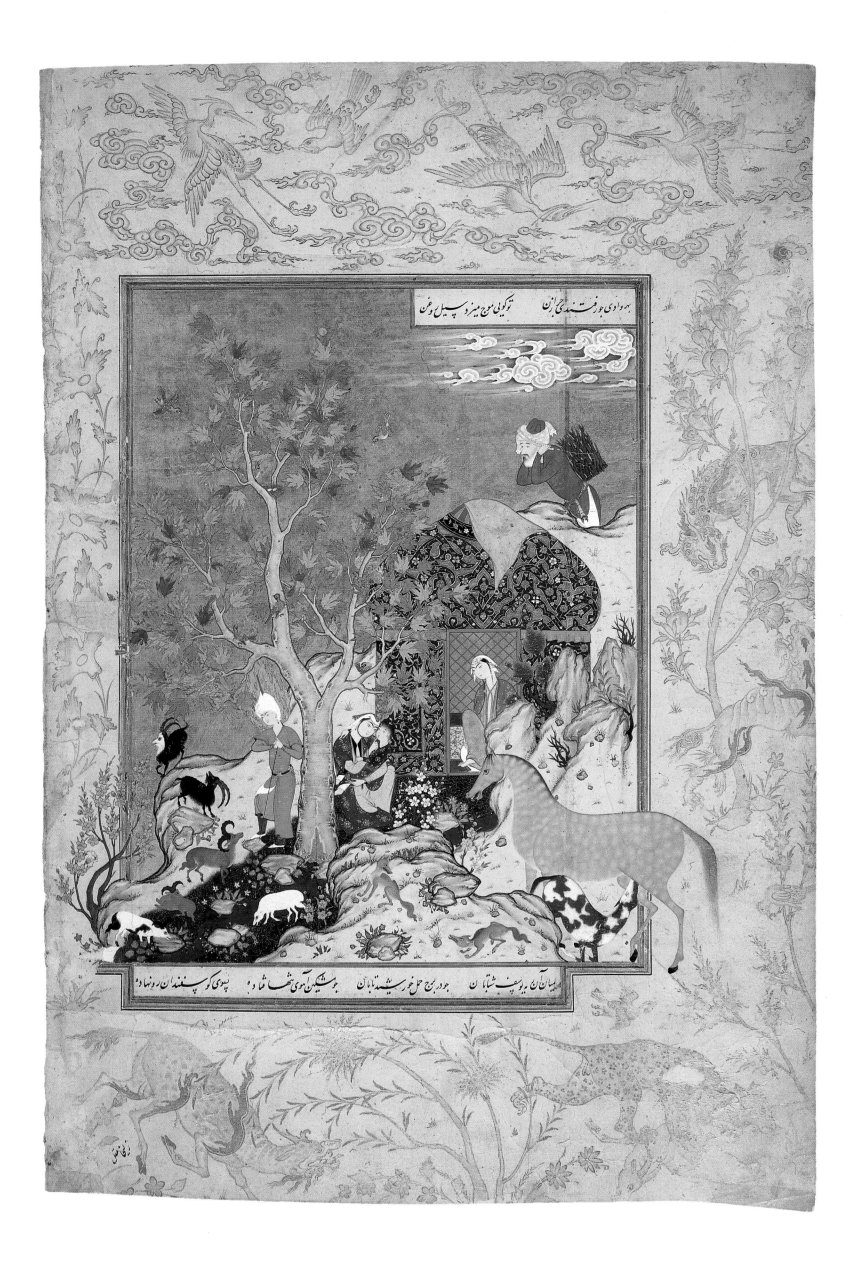

Folio 114b

YUSUF PREACHES TO ZULAYKHA'S MAIDENS IN HER GARDEN

23.7 x 15.9 cm

Inscribed on facade archway:

Upon this emerald arch there is a pre-eternal inscription:
"Everything that [exists] is dependent upon Ali and his family."

Having failed to seduce Yusuf on her own, Zulaykha resorts to surrogates and even more deceptive stratagems. She arranges for Yusuf to enter her beautiful enclosed garden and then sends along one hundred pretty maidens to entertain the youth. Imagining that Yusuf will fancy one of the girls, Zulaykha plans to secretly change places with the favored maiden and finally achieve her heart's desire. Once again Yusuf recognizes and foils her ruse, and instead of yielding to the maidens' charms, he spends the night preaching to them about the mercy and wisdom of God. He also teaches the girls to recite the *shahada*, the profession of the faith of Islam, and leads them to acceptance of the one true God.

Yusuf sits on the terrace of a large garden pavilion and gestures outward in speech to a group of Zulaykha's maidens. The lighted tapers, the crescent moon at the sky's upper edge, and the blue and white candlestick behind Yusuf indicate that it is still dark in the garden. Some of the young women seem to be paying more attention to one another than to their guest, but Zulaykha, leaning out of a window at the upper right, certainly is concentrating intently on the scene below.

Although in its overall representation the painting closely follows the text, there are few specific details that convey the message of conversion and redemption. The lack of any direct visual signs is compensated for by the couplet inscribed on the facade in which the word "arch" may refer metaphorically to the vault of heavens. The brick and tile archway thus takes on new significance as a terrestrial mirror image of heaven's arch. The role of the inscription within the illustration may be to emphasize the spiritual nature of Yusuf's discourse with Zulaykha's maidens and Jami's overall theme of the power of divine love.

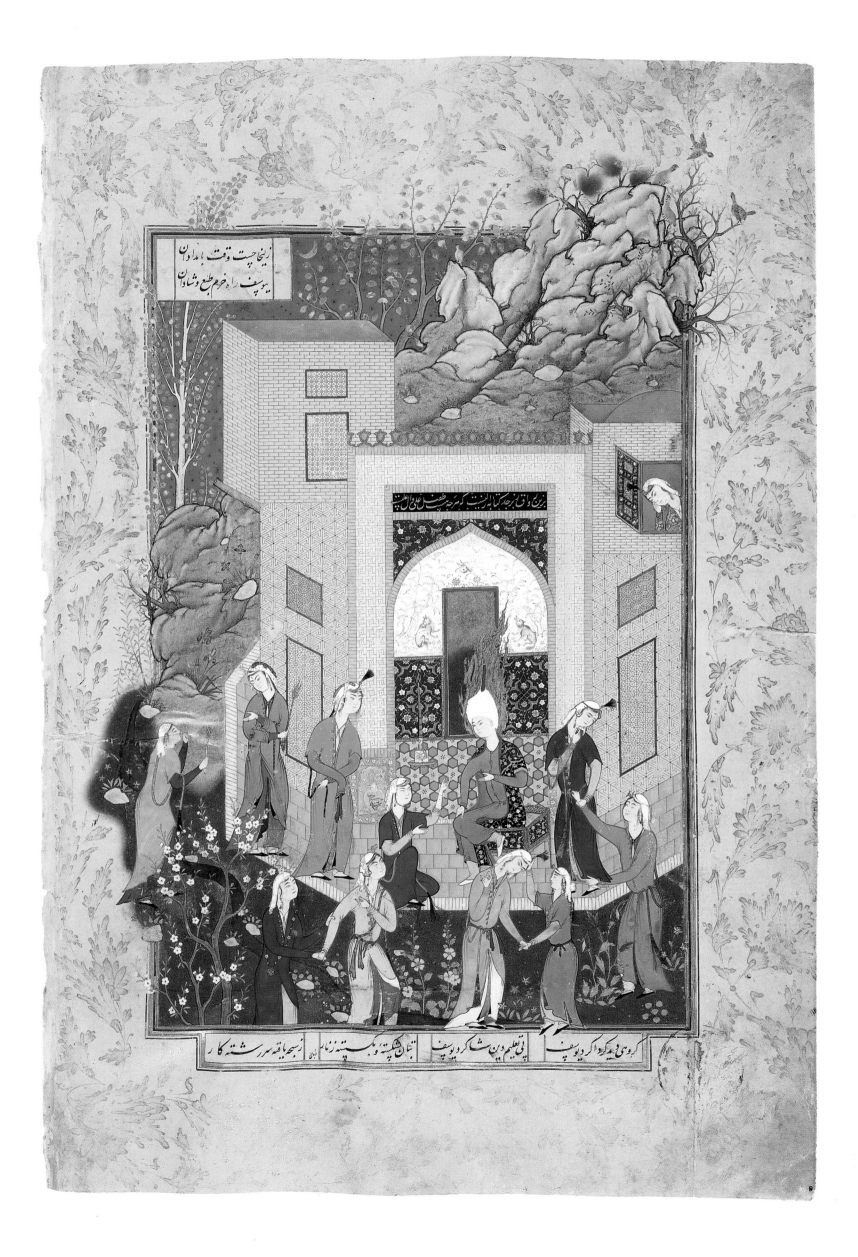

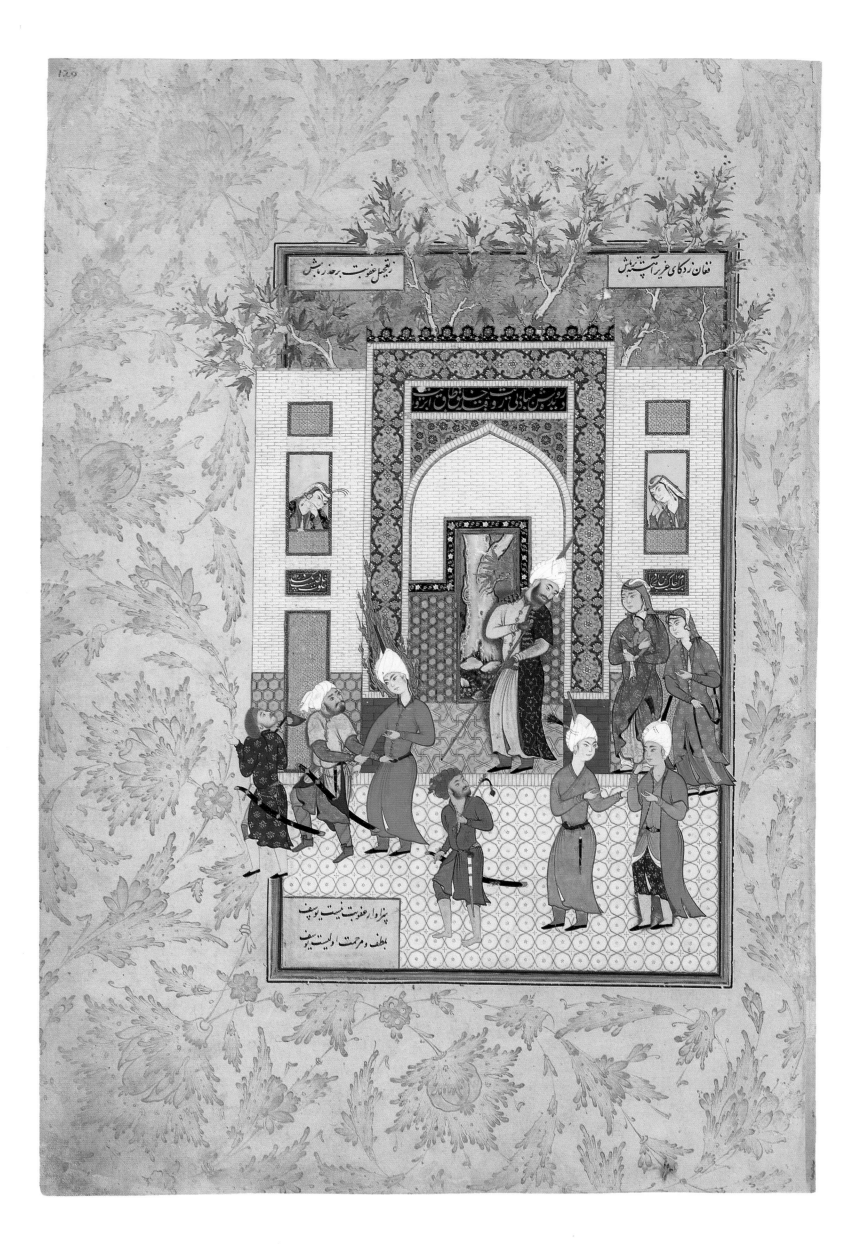

Folio 120a

THE INFANT WITNESS TESTIFIES TO YUSUF'S INNOCENCE
21.6 x 14 cm

Inscribed over central arch on facade:

> *May [no] eye be graced with light without [the sight of] your face;*
> *The arch of your eyebrow is the qibla of the people.*

Inscribed over side doors:

> *Tear [open] my breast [and] enter here.*
> *It is a most private place of seclusion, open the door and come in.*

Signed to left of inscription over central arch:

> *Written by Shaykh-Muhammad [the] painter*

In her continuing efforts to seduce Yusuf, Zulaykha lures the youth into her magnificent palace. Yusuf is on the verge of yielding to her passionate advances when he suddenly becomes aware that she worships idols. He quickly breaks out of Zulaykha's embrace and flees the palace with the seductress in hot pursuit. Outside they encounter Zulaykha's husband the *aziz*, and the frustrated woman accuses Yusuf of having tried to ravish her. Deceived by his wife, the *aziz* orders Yusuf to be imprisoned, notwithstanding the youth's protestations of innocence. The palace guards begin to lead Yusuf away when a three-month-old baby, the son of one of Zulaykha's attendants, loudly (and miraculously) proclaims Yusuf's innocence and cautions the *aziz* against punishing the youth.

This dramatic revelation occurs in front of Zulaykha's palace, with the bearded *aziz* standing under the central archway and turning back toward the child held in the arms of a woman to the right. The infant witness, gesturing in speech and wearing a high conical hat, looks more like a miniature adult than a suckling baby. As the *aziz* listens to the babe's testimony, Yusuf is escorted off the terrace by armed guards. Zulaykha—the other principal figure in this episode—is less easily identifiable; she may be the woman with the fancy headdress leaning out of the left-hand window.

As in other Freer Jami illustrations, the scene is raised from the literal to the literary by a couplet, which is not from the *Haft awrang*, inscribed on the palace facade. The verse constitutes both a punning reference to the architecture on which it is written (the archway) and its metaphorical counterpart (the *qibla* niche in a mosque indicating the direction of prayer), and a paean to Yusuf and his future position as a prophet. The first line is particularly apt since Jami uses light images throughout *Yusuf and Zulaykha* and stresses that joy and beauty are eclipsed whenever Yusuf is confined.

Shaykh-Muhammad was a versatile Safavid artist known to have worked for Sultan Ibrahim Mirza. His minute signature, contained within a brick to the left of the central arch inscription, indicates that he transcribed the verse. The word "painter" after his name also suggests that Shaykh-Muhammad may have designed and executed the entire illustration. Was he playing a game or trick on his princely patron in hiding his name so cleverly?

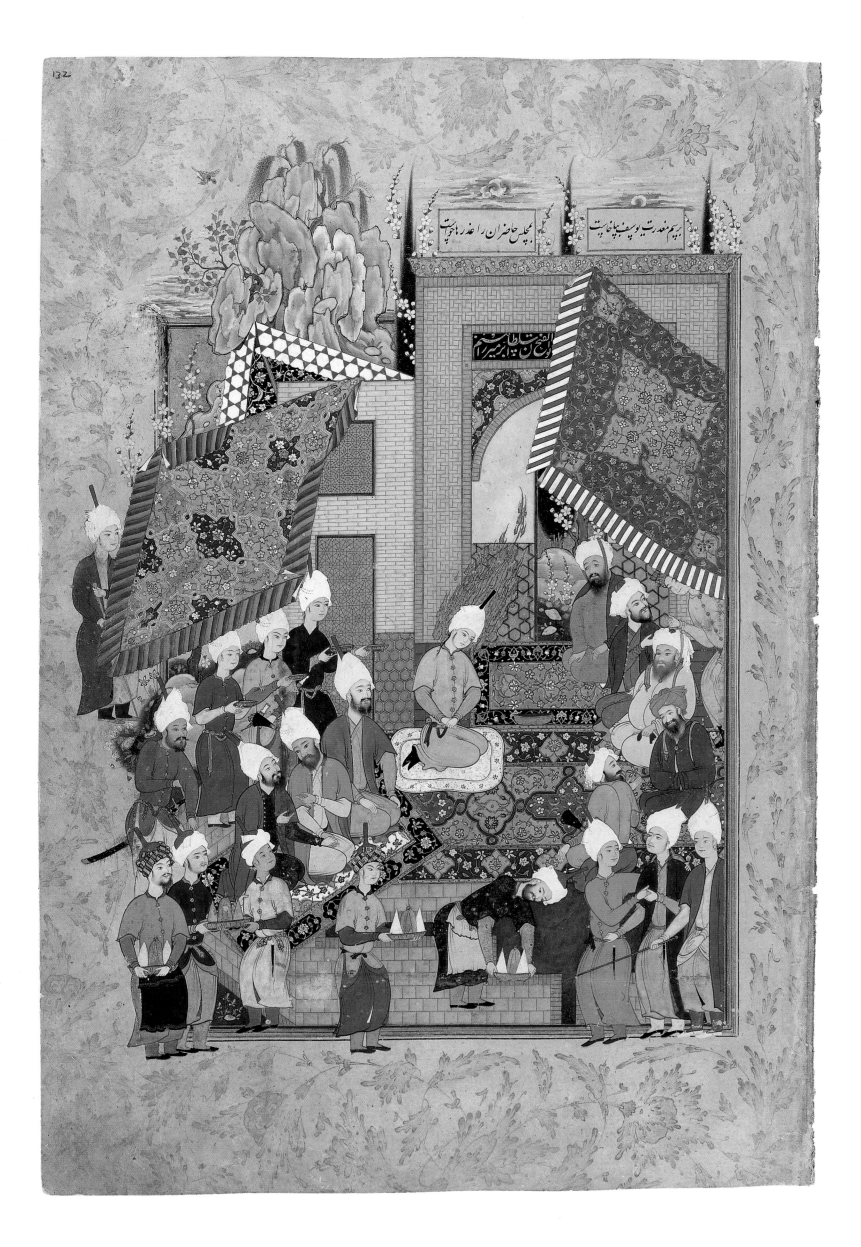

Folio 132a

YUSUF GIVES A ROYAL BANQUET IN HONOR OF HIS MARRIAGE
27 x 19.4 cm

Inscribed over archway:

Abu 'l-Fath Sultan Ibrahim Mirza

After many years of suffering for Zulaykha and of honor and glory for Yusuf, the two met again. Aged and blind, Zulaykha still loves Yusuf (who has remained young) and expresses her desire to live with him forever. Through his prayers, Yusuf is able to restore Zulaykha's sight, youth, and beauty but feels torn between his commitment to purity and his vow to help her. All hesitations are removed, however, when the angel Gabriel brings a divine command that Yusuf should unite himself in marriage to Zulaykha. Thereupon Yusuf prepares a banquet to which he invites the Egyptian king and other dignitaries.

As represented here, Yusuf's wedding party consists of an all-male gathering on a richly appointed terrace. Yusuf occupies the most prominent spot in the assembly, kneeling on a small white rug, his hands clasped together. As in all the other *Yusuf and Zulaykha* illustrations in the Freer Jami, Yusuf's head is surrounded by golden flames—a sign of his sanctity. The seated guests include three courtiers to the groom's right and five clerics in front. Standing attendants at the lower edge hold platters with sugar cones and other sweets traditionally offered at weddings in Iran.

Like the illustration of Zulaykha's bridal entourage (folio 100b), this beautiful painting may relate directly to the marriage of Sultan Ibrahim Mirza, patron of the Freer Jami, and Gawhar-Sultan Khanim, his cousin and the daughter of Shah Tahmasp. Here the possibility is strengthened by the presence of the prince's name over Yusuf's head. Sixteenth-century sources tell us that the arrival of Gawhar-Sultan at Mashhad, where Ibrahim Mirza had recently been appointed governor, was celebrated for several months before the marriage was actually consummated. It is likely that the festivities would have involved different kinds of parties, primarily all-male affairs. One can imagine, for instance, that Sultan Ibrahim Mirza might have given a reception in honor of his bride's male escorts and invited clerics from the famous Imam Reza shrine in Mashhad. That this illustration reflects such a fête would explain the absence of the king mentioned in Jami's narrative of Yusuf's banquet, since Shah Tahmasp did not accompany his daughter to Mashhad.

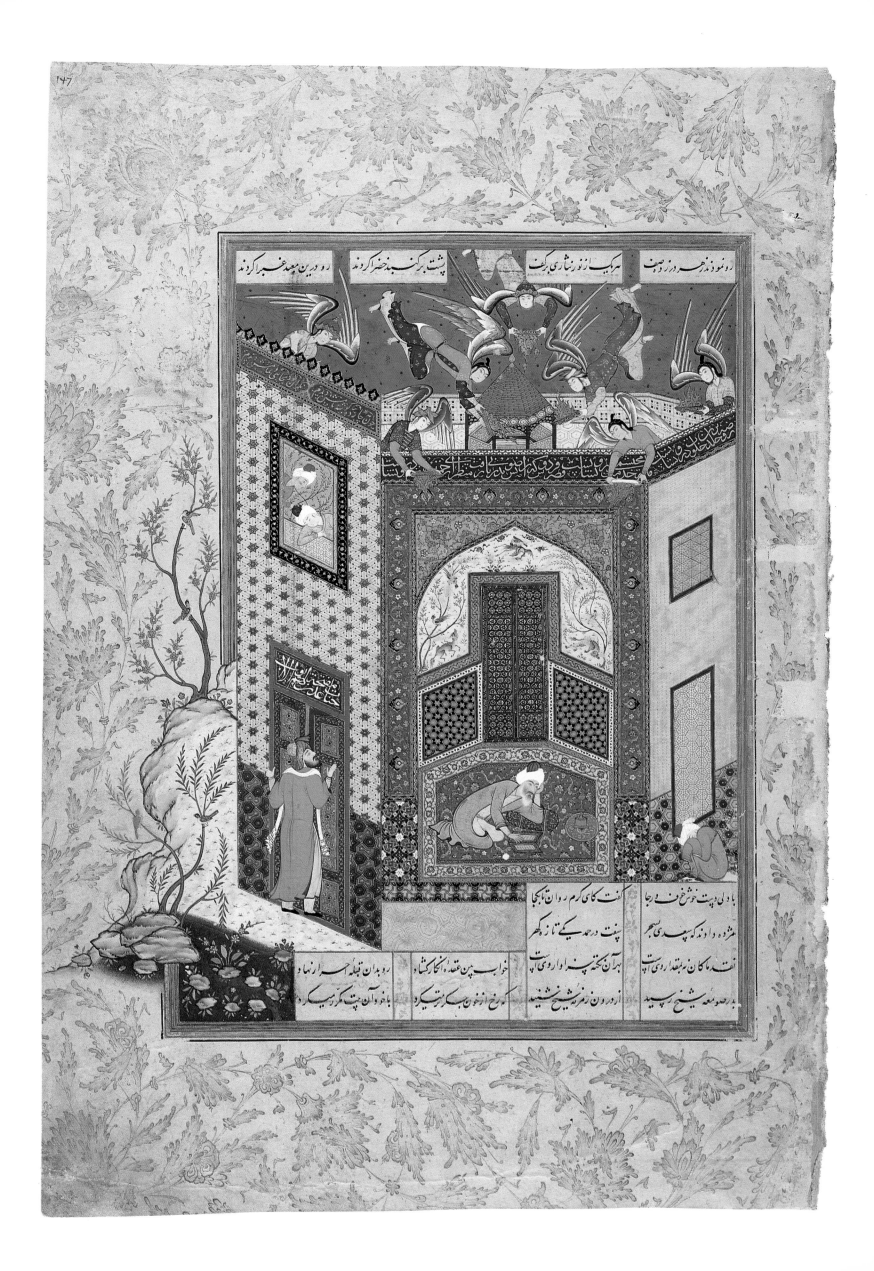

Folio 147a

THE GNOSTIC HAS A VISION OF ANGELS CARRYING TRAYS OF LIGHT TO THE POET SA^cDI

23.1 x 16.7 cm

Inscribed over door [Koran 38:50]:

Gardens of Eden, whereof the gates are opened for them.

Inscribed on cornice at right and center:

The solitary retreat of the dervishes is the garden of paradise above;
To serve dervishes is the leaven of pomp [meritorious].

The castle of paradise to which Rezvan is the gatekeeper
Is a belvedere for the mercy of the dervishes.

Inscribed on cornice at left:

When I saw him like the full moon at the edge of the roof,
He was looking for something, and I saw him complete [like the full moon].

This painting illustrates a passage in *Subhat al-abrar* (Rosary of the pious), one of Jami's didactic *masnavis* concerning the progression of the soul toward union with God. One night the famous poet Sa^cdi writes a verse in praise of God. A gnostic, or mystic, troubled in his belief in the divine, dreams that a group of angels are coming down from heaven and carrying coins of light. The gnostic asks the heavenly spirits where they are going, and they reply that Sa^cdi has written a new verse to God and that they are taking a gift from heaven to him. The man then goes to the door of Sa^cdi's dwelling and overhears the poet reciting the very verse for which he was rewarded by the angels in the dream. The lesson of this story is that pious poets have the capacity to create works of great spirituality and assuage the doubts of those seeking enlightenment.

This painting reveals considerable artistic sensitivity to the theme of the pure and divine nature of poetry. The idea of a verse, such as the one Sa^cdi has composed, as a source of spiritual enlightenment is implicit in the flaming trays held by the angels swooping down onto the roof of the poet's abode. While they obviously illustrate radiant rewards from heaven, they also signify the guiding light that Sa^cdi's verse provided to the gnostic. The various inscriptions on the building also reinforce the general theme of Jami's text, including the Koranic verse over the door that describes the rewards of paradise reserved for all true believers in the faith of Islam. Clearly Sa^cdi is considered as blessed and the gnostic as one who has heeded the word of God and escaped the tortures of the damned.

Folio 153b

THE PIR REJECTS THE DUCKS BROUGHT AS PRESENTS BY THE MURID

23.9 x 17.4 cm

To save his soul, a powerful monarch becomes the *murid*, or pupil, of a pious dervish. The king takes a hundred gifts to his *pir*, or master, who accepts none. One day the king goes hunting and catches several ducks with his falcon. These he also offers to the *pir*, only to be spurned again. In the eyes of the ascetic, the king lives by tyranny, so nothing he does is right and nothing he touches is pure.

The encounter between *pir* and pupil takes place at a cave in the middle of a rocky hillside. The white-bearded ascetic, gaunt and bareheaded, kneels inside the entrance to the cave and gestures to a dead duck lying on its side. In front to the left is a small vessel with double handles and a spigot, which may have been one of the king's previous offerings. From the top of the cave hangs a leather water bottle, its expanded sides indicating the *pir*'s abstinence. To the left stands a dark-skinned man whose humble demeanor marks him as a disciple to the *pir*.

The king, in elegant attire, kneels immediately outside the cave, his falcon perched on one gloved hand. Behind him stands a youthful attendant who holds a second falcon beating the air with its wings. Three other pairs of royal retainers approach the cave up a sloping path. The surrounding landscape teems with animals and people, many of whom are engaged in hunting. While all the falconers and hunters in this scene may be the normal retinue of a royal hunting party, they may also serve to reinforce the point about the king's intrinsic unworthiness (since he engages in and supports hunting) as contrasted with the *pir*'s abstinence and purity.

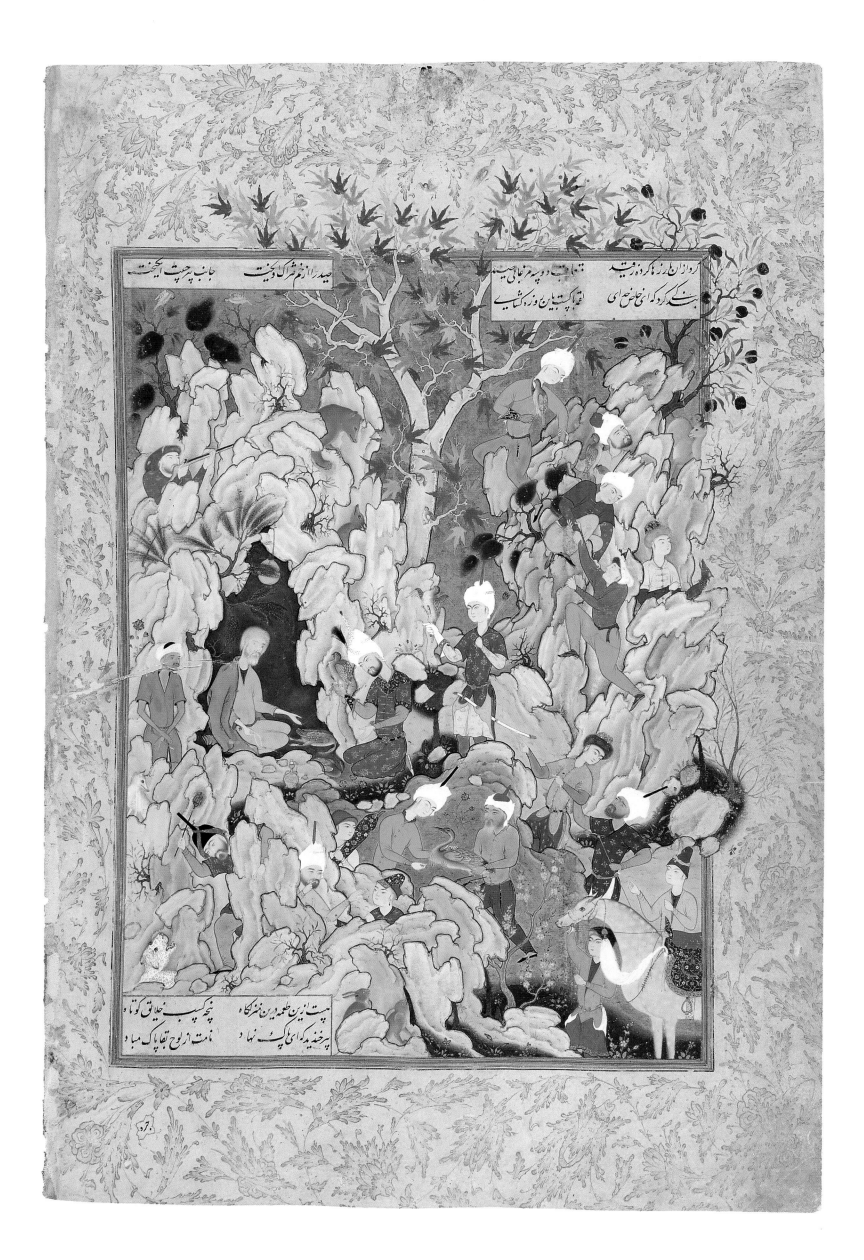

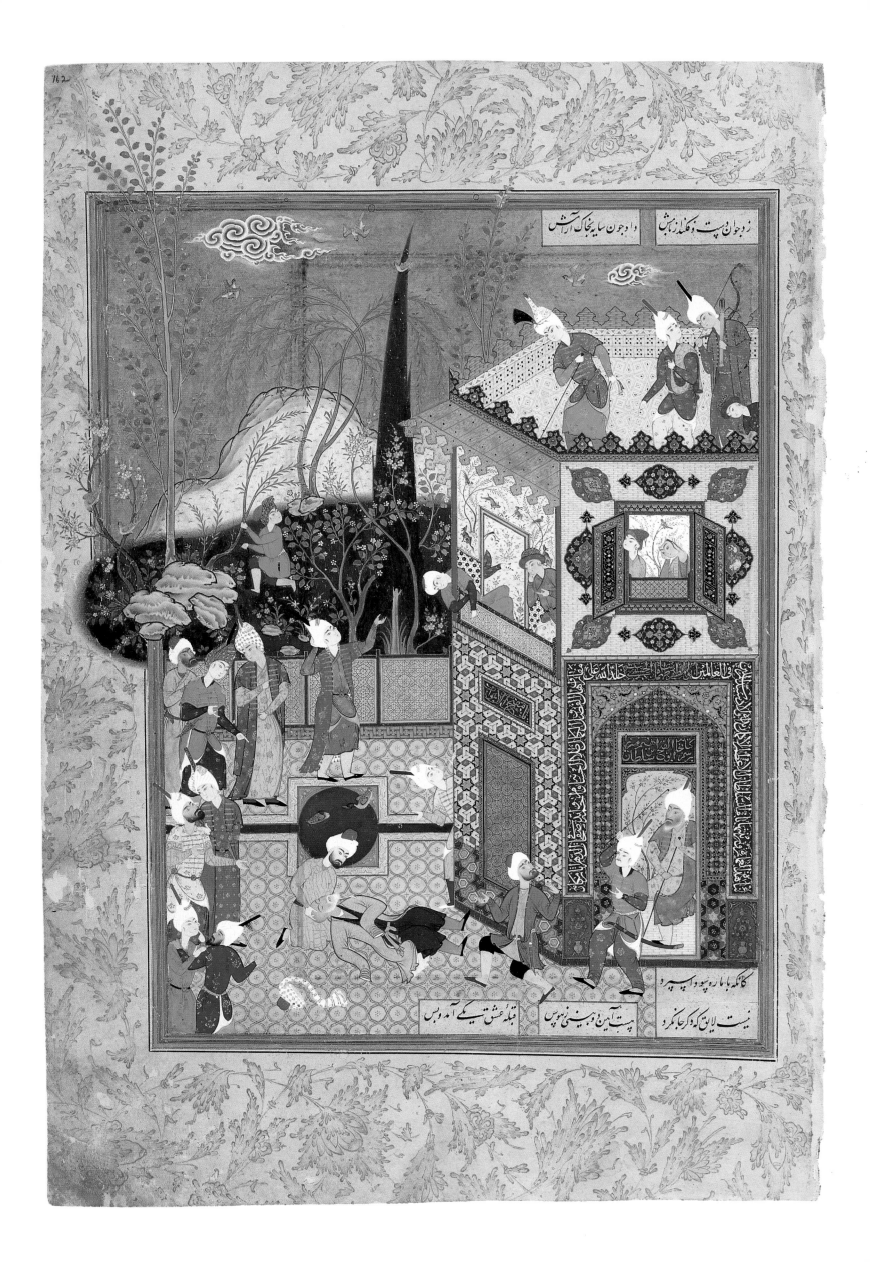

Folio 162a

THE FICKLE OLD LOVER IS KNOCKED OFF THE ROOFTOP
24.8 x 19.4 cm

Inscribed on left-hand wall:

Oh, opener of doors [of paradise]

Inscribed around door frame:

The building of this structure and its decoration [was done] by order of the mightiest and most perfect sultan, Abu 'l-Muzaffar Shah Tahmasp al-Husayni, may the offsprings of the lord of apostles [Muhammad] support him in this world and the next. May God perpetuate the shadow of his beneficence and mercy over the crowns of heads of people of knowledge and excellence and [may God] support the traces of his generous works through the pages of time.

Inscribed over door:

By order of the kitabkhana of Abu 'l-Fath Sultan Ibrahim Mirza

This painting illustrates a section of *Subhat al-abrar* that concerns the attraction of the loving spirit toward the "beauty of essence." Jami explicates his ideas with an anecdote about a crookbacked old man who declares his passion for a handsome youth standing on a rooftop. In reply, the boy tells the old man to turn around and look at someone even more beautiful. When the old man starts to do so, the youth knocks him off the roof and he falls flat on the ground. The violent rebuff is intended to teach the aged suitor that it is impossible to have more than one true love.

The painting depicts the moment when the fickle old man has landed on the ground alongside the youth's dwelling and is being comforted by a passerby. The elegantly attired youth leaning on a staff and looking down from the roof is probably the main protagonist of Jami's anecdote. Groups of curious bystanders have gathered on the terrace, while others peer down from the building's roof, window, and balcony.

As in the illustration to the *Silsilat al-dhahab* story of the peasant selling his donkey (folio 38b), this painting contains inscriptions evoking God's blessing on Shah Tahmasp and recording Sultan Ibrahim Mirza as the manuscript's patron. The ostensible purpose of these inscriptions is to proclaim the relationship between the king and the prince. It is telling, however, that both this scene and the one earlier in the Freer Jami illustrate anecdotes concerning foolish old men.

Folio 169b

THE ARAB BERATES HIS GUESTS FOR ATTEMPTING TO PAY HIM FOR HIS HOSPITALITY

26.2 X 19 cm

A desert Arab provides generously for an unexpected group of travelers, sacrificing a camel on each day of their stay. One day he mounts his camel and takes off from camp. Upon his return he discovers that the guests have departed, leaving a sack of gold with his family as payment. The Arab grabs the sack and his spear and rides off after the travelers, cursing them for trying to repay his hospitality. He also threatens to kill them if they do not take the money back. The travelers have no choice but to reclaim the sack before continuing on their way.

This story serves as an apologue to a *Subhat al-abrar* passage on "liberal giving and munificence," which Jami casts as one of the stages toward reaching perfect love of God. The accompanying illustration is quite faithful to the literal content of the poem except that the final encounter between the angry host and his guests seems to be taking place in front of the Arab's home. The setting is represented by a finely striped black felt tent pitched in the right background with a woman and little boy, presumably members of the Arab's family, standing in the entrance. Down in front the bearded Arab, mounted on camelback, rides up to a group of six horsemen, who are moving off at a leisurely pace, obviously not expecting confrontation. The extent of the host's displeasure is not immediately apparent, but a spear rests over his shoulder and a white sack hangs from his hand. One rider turns back to meet the Arab, gesturing outward in speech. This youthful figure is probably the ranking member of the group, judging from his distinctive turban and fancy horse trappings.

This painting contains no extraneous features that might extend the subject or reinforce the moral of the *Subhat al-abrar* tale. Its iconographic simplicity is matched by crystalline clarity and precise draftsmanship. The rendering of textile patterns, especially the saddle blankets, is particularly noteworthy.

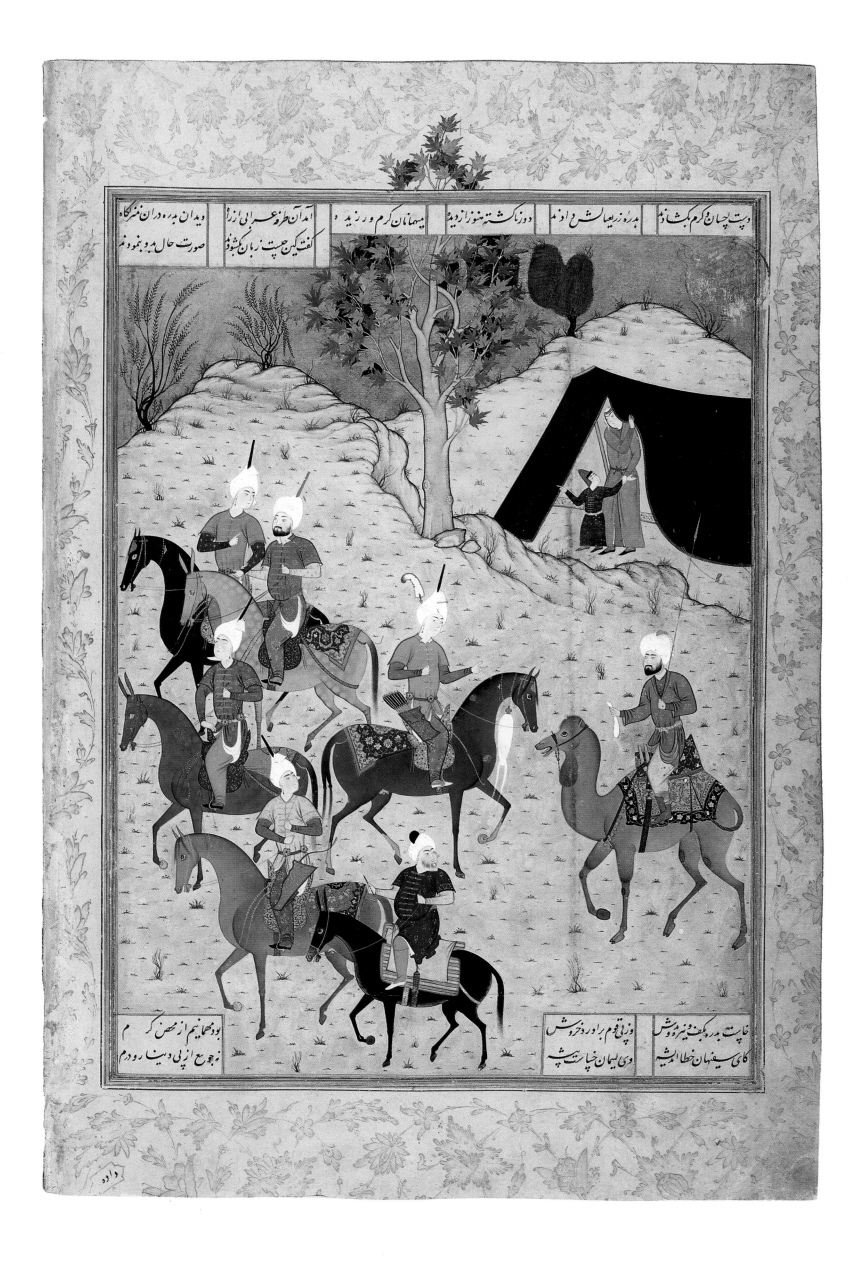

Folio 179b

THE TOWNSMAN ROBS THE VILLAGER'S ORCHARD

24.5 x 15.6 cm

The seemingly bucolic setting of this painting belies the tension of its subject matter. The *Subhat al-abrar* tale concerns a *dihqan*, or landlord, who invites a city dweller to his garden. The orchard is "adorned like the garden of paradise," with rich grapevines and trees laden with apples, pears, and pomegranates. At the sight of such bounty the visiting townsman goes berserk, breaking off branches, yanking off fruits, and ravaging vines. The villager watches this gratuitous despoliation in agony and does not know how to stop his visitor. How could someone from the city comprehend a villager's feeling when he has never planted a seed, pruned a tree, gotten blisters from the spade, or spent long nights irrigating plants? "Who shares [my] pain," says the *dihqan*, "knows [my] pain, [but] the description of it is dull to those who do not feel the pain."

The stoic *dihqan* stands within his enclosed orchard, gesturing outward as if in resignation to the city dweller who pulls down the slender branch of a pomegranate tree and plucks off a fruit. Two other limbs hang at an unnatural angle, further evidence of the visitor's ruthlessness. Looking like he has come prepared to do dirty business, the townsman wears work clothes and has a stick at his waist and a sack draped over his shoulder. Although he has a garden implement stuck in his sash, the *diqhan* looks more like a refined city gentleman and the townsman like a rough-hewn country fellow—as if the artist had deliberately switched the traditional attire of the two characters.

The primary action of this *Haft awrang* illustration is bracketed by two contrasting scenes. At the top of the composition four youths relax in a pavilion, a familiar vignette in Persian painting that reinforces the image of the garden as paradise. At the orchard doorway below a gardener gives a bunch of grapes to a passing beggar, an act of charity that surely would have been lost on the city dweller who had no compassion for the villager and no understanding of the effect of his greed.

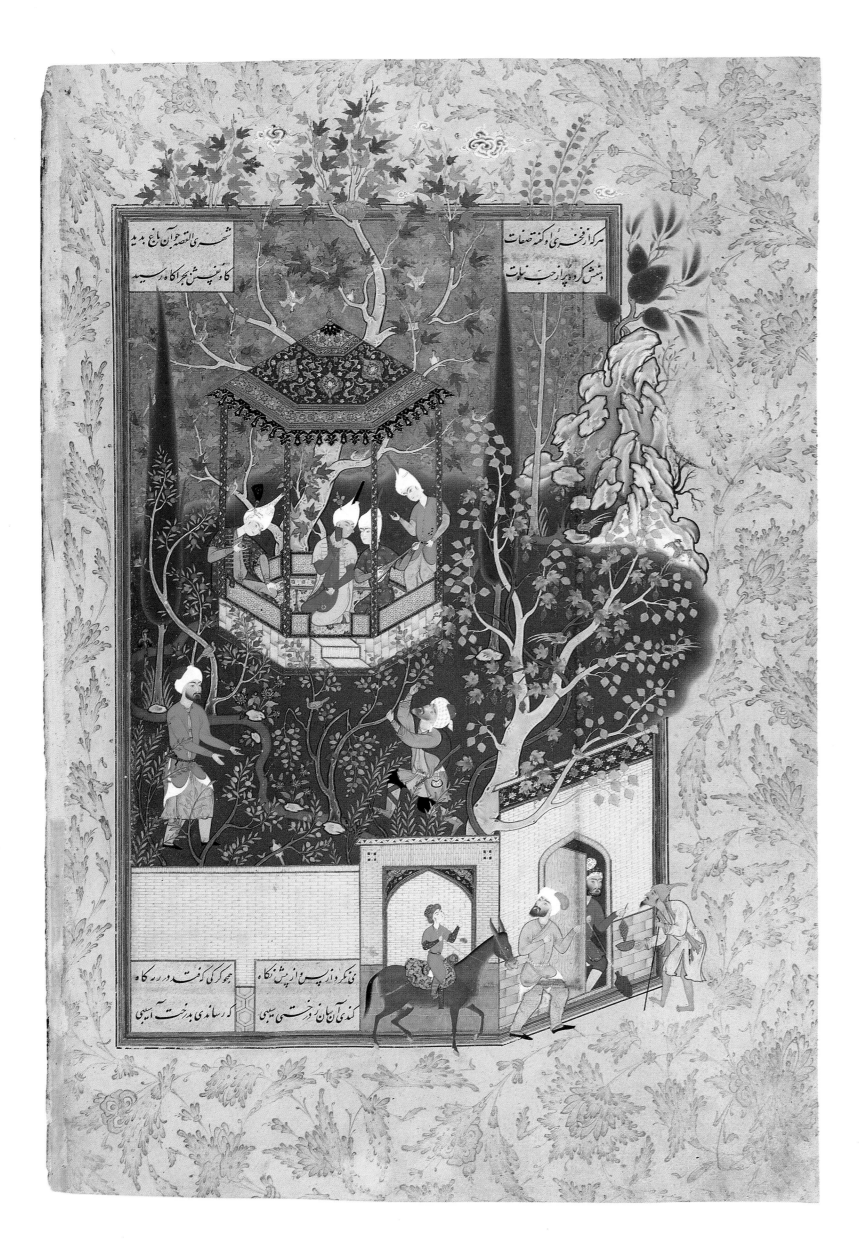

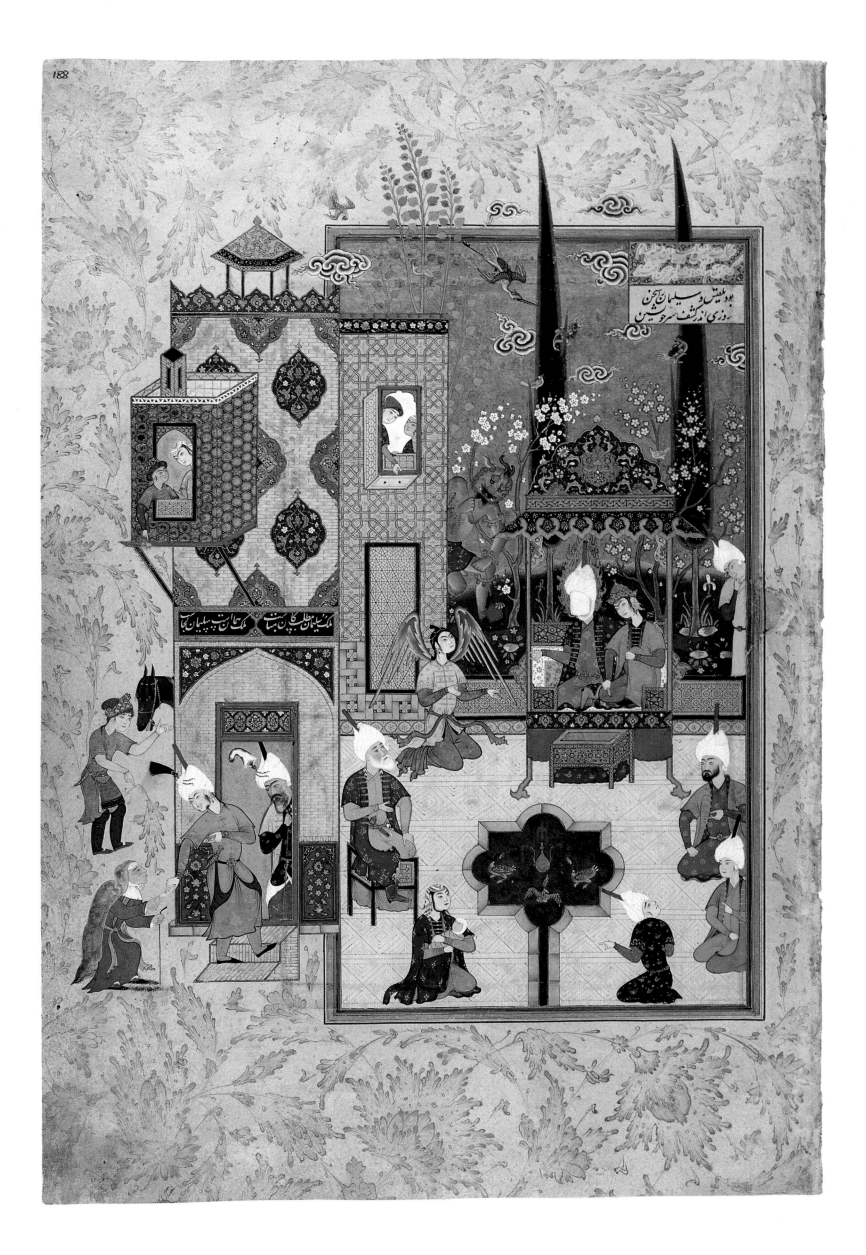

Folio 188a

SOLOMON AND BILQIS SIT TOGETHER AND CONVERSE FRANKLY

23 x 18.7 cm

Inscribed over door:

Seek not the kingdom of Solomon, for it is dust.
The kingdom is [still] there, but where is Solomon?

Like Yusuf (Joseph), King Solomon is another personage from Judeo-Christian tradition who figures prominently in the arts and cultures of the Islamic world, including Persian literature. Jami features Solomon several times in the *Haft awrang*, here, in the *Salaman and Absal* poem, in a passage in which the poet condemns women as full of passion and vice. The specific story concerns King Solomon and the queen of Sheba (known in Iran as Bilqis), who are exchanging their innermost secrets. Solomon confesses that, despite his power, he always looks first at the presents brought by visitors. Bilqis, in her turn, confides that she longs for every young man passing by. Thus the two reveal a mutual need for gratification.

Solomon and Bilqis appear regularly in classical Persian painting, although the royal pair more often graces manuscript frontispieces than narrative text illustrations. The imagery of this painting, in which the king and queen are seated side-by-side on a palace terrace, actually draws upon standardized representations of the two and includes elements derived from Solomonic lore that Jami does not mention. Solomon's face, for instance, is covered with a white cloth and his head framed by a flaming nimbus—both signs of his sanctity and prophethood. The winged angel seated near the throne and the hoary *div*, or demon, in the garden behind also relate to Solomon's legendary authority over creatures of heaven and earth. His reputation for wisdom and justice is signified by the elderly gentleman seated on the terrace, identifiable as Asraf ibn Barakiya, who served King Solomon as vizier or minister, and by the aged woman presenting a petition at the palace door to the left. In all likelihood the woman holding a baby in her arms refers to Solomon's celebrated proposal to split a child between two contesting mothers. Notwithstanding Solomon's power and glory, the verse inscribed over the door reminds us that these attributes are only temporary and correspond to Jami's Sufi philosophy about the futility of striving for worldly possessions.

Folio 194b

SALAMAN AND ABSAL REPOSE ON THE HAPPY ISLE
22.7 x 19 cm

The narrative of Jami's *Salaman and Absal* poem relates how the king of Greece turns for advice to a renowned philosopher and confides his yearning for a son. The sage responds with a lengthy discourse on the nature of passion and the evils it can bring—a soliloquy punctuated by the anecdote of King Solomon and Bilqis (folio 188a). Eventually the king of Greece has a son whose appearance is so perfect that he is called Salaman, from the word *salamat*, meaning "wholeness" or "health." The baby is suckled by Absal, a nurse who falls in love with her beautiful charge as he grows older. At first Salaman resists Absal's declarations of passion but later succumbs to his own newly awakened desires. Before long both the king and the sage hear of Salaman and Absal's conduct and admonish the boy to realize his princely rank and inner worth. Salaman reacts by abandoning his father and adviser and fleeing with Absal to a distant island.

Jami characterizes the lovers' refuge as a "happy isle," a lovely and tranquil spot full of springs, trees, fruit, and birds. This representation of the island is every bit as lush as Jami describes and includes many different kinds of flora and fauna. The silver waves (now darkened through oxidization) lapping at the island's shore also teem with aquatic life. Having disembarked from their skiff, Salaman and Absal seem to be taking stock of their surroundings. There is no doubt that they have arrived at an idyllic spot, removed from the rest of the world. Yet various details in the illustration allude to the censure the lovers have fled and give portent of future grief. The swan flapping its wings toward the sky, the snake devouring a fish, and the rabbit snarling on the lower shore may be normal signs of nature in the wild, yet they also signify struggle and conflict. Indeed, in an anecdote related at the beginning of the *Salaman and Absal* poem, sea creatures are described as impure. That Salaman and Absal embarked on a sea of animal passions is reinforced by the roiling waters and further reflected by the racing clouds above. The hero himself strikes a particularly discordant note with his bow and arrow as if he is about to disturb the tranquility of his refuge. Absal seems unconcerned, but a large monkey chattering under an apple tree surely must be reprimanding Salaman for thoughtlessly shattering the peace of the happy isle.

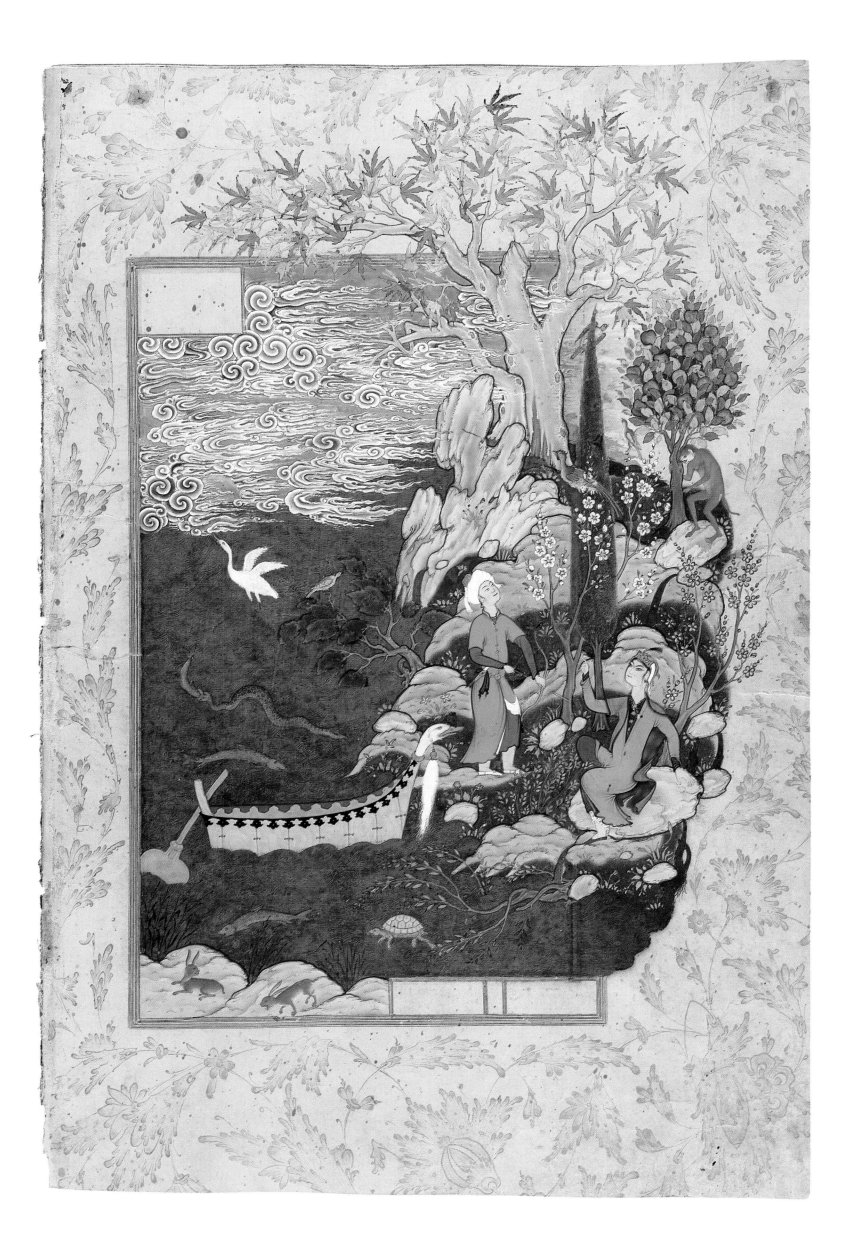

Folio 207b

THE MURID KISSES THE PIR'S FEET

21.6 x 13.2 cm

From time to time throughout the *Haft awrang*, Jami becomes self-referential and speaks in the first person about his own feelings and concerns. At the beginning of the *Tuhfat al-ahrar* (Gift of the free) *masnavi* the poet describes a moment when he was overcome with remorse at his lack of faith. As he prayed to God for guidance, "the light of relief" appeared in the person of a *pir*, or spiritual master. Now filled with the "light of certainty," the poet fell to his feet and rubbed his face on the *pir*'s sandals. The master urged Jami not to be troubled by doubts and fears. He, the *pir*, would be his friend and physician so that Jami, the *murid* or disciple, might receive enlightenment through unity with God. As Jami explains in a previous passage of *Tuhfat al-ahrar*, those who wish to penetrate to the essence of the divine need the true knowledge that can be gained through close association with a spiritual master. In the last line of this discussion Jami urges himself to strive for knowledge and to turn to such a *pir*.

Among the most straightforward scenes in the Freer Jami, this illustration is comparable in its iconographic precision and compositional clarity to *The Wise Old Man Chides a Foolish Youth* (folio 10a) and *The Arab Berates His Guests for Attempting to Pay Him for His Hospitality* (folio 169b). Since Jami does not describe the location of this event, the artist was obliged to create an appropriate setting, complete with witnesses. The youth carrying the taper at the entrance to the building indicates that this is a night scene, as stated in the text. This figure may also personify the light imagery Jami uses in his poem and, more specifically, the illumination cast by the *pir* and the enlightenment attained by the *murid*.

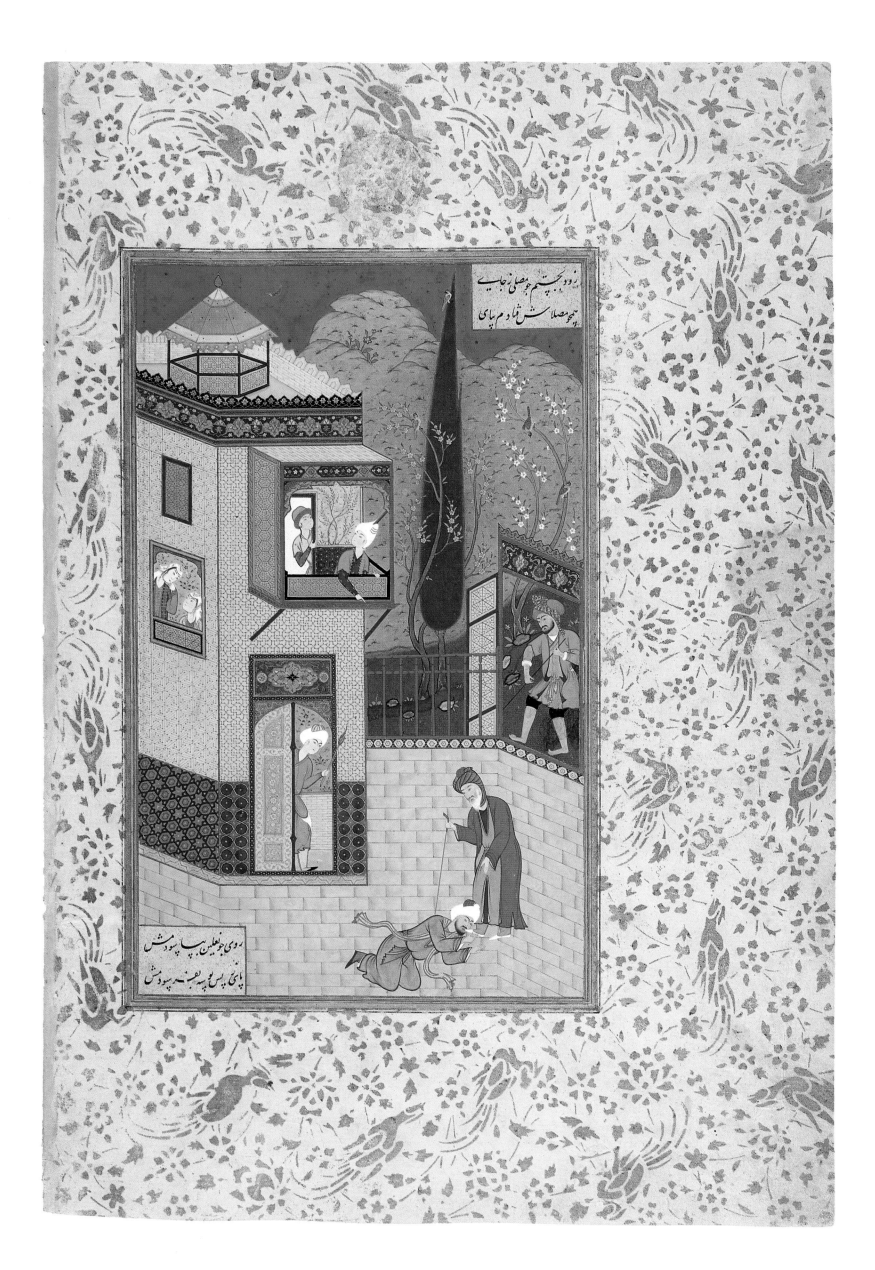

Folio 215b

THE FLIGHT OF THE TORTOISE

21.7 x 19.5 cm

A tortoise befriends two ducks on a riverbank. After a while the ducks yearn to fly away, and the tortoise begins to grieve at the prospect of his friends' departure. Fortunately the ducks find a way for the tortoise to go with them. Each seizes one end of a stick from a nearby thicket and has the tortoise clamp onto the middle with his teeth. The trio then takes off into the air over dry land and flies above a crowd of people, who marvel at the sight. The tortoise opens his mouth to tell the onlookers not to be envious and consequently loses his grip and falls to the ground. The moral, says the poet Jami, is that thoughtless speech can cause a downfall.

This amusing parable comes from the ancient literary genre of the mirror for princes, in which animal fables are used to instruct kings about proper conduct. Jami's version of this popular tale accompanies a discourse of *Tuhfat al-ahrar* that ends with an exhortation not to speak in vain—a point reinterated by what happened to the tortoise.

The composition illustrates the moment just before the tortoise's fall and, as with the *Tuhfat al-ahrar* text itself, follows a well-established iconographic tradition. Like many sixteenth-century representations, including a number in *Haft awrang* manuscripts, the principal action of the tortoise hanging onto a stick being supported by two ducks is relegated to a small quadrant of sky. The illustration is really about the excited reactions of the onlookers who fill the expansive landscape and cluster inside and around the large bulbous tent. Only the woman bending over her needlework seems totally oblivious to the marvelous scene taking place overhead.

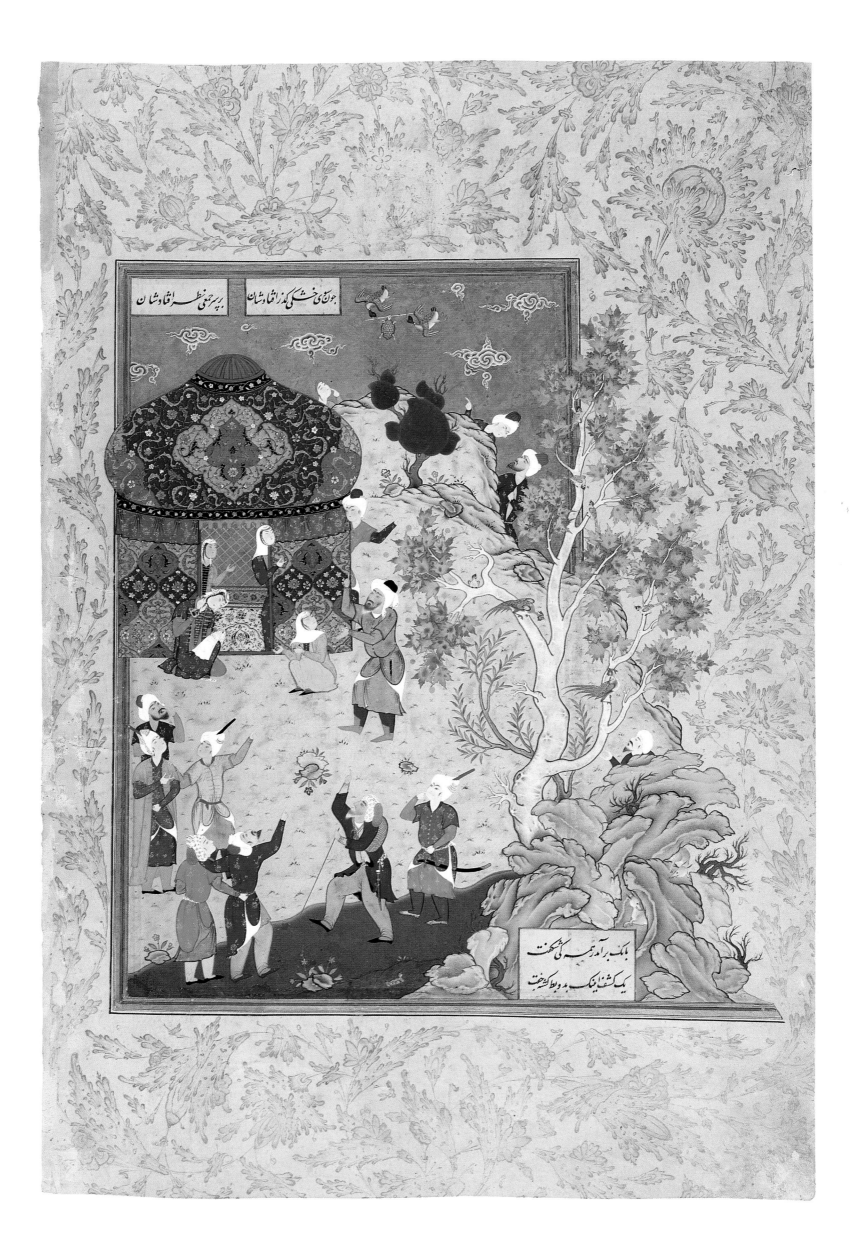

Folio 221b

THE EAST AFRICAN LOOKS AT HIMSELF IN THE MIRROR
24 x 13.7 cm

The *Tuhfat al-ahrar* poem contains a discourse about beauty and the allure of the beloved (that is, God). When people behold beauty, Jami says, they are looking at their own desire. Since that desire is selfish and holds no light, their eyes soon become satiated and their mirror (the beautiful beloved who is the object of their gaze) turns into torment. Jami emphasizes the point of this discourse with a brief tale about an ugly East African (meaning a black person) who finds a dirty mirror beside the road and cleans it off. When he looks into its shining surface, he begins to curse, thinking that the loathsome reflection is the fault of the mirror. The moral, according to Jami, is that what you see is the image of your own actions.

In this illustration a tall, gangling dark-skinned youth stands alongside a stream and holds a mirror. (The silver paint of both stream and mirror has oxidized and blackened.) A large gold hoop earring, signifying servitude, adorns his left ear. His lips are extremely thick, a characteristic mentioned by Jami, and his eyes are conspicuously protuberant. The youth certainly seems disgruntled as he gazes into the mirror.

Sixteenth-century Persian painting is full of dark-skinned personages, usually in subsidiary positions such as the attendants on the roof of the bathhouse in *The Dervish Picks Up His Beloved's Hair from the Hamman Floor* (folio 59a). The representation of this *Tuhfat al-ahrar* scene is, however, a rare and possibly unique instance of a Negro as a principal character. Within Safavid manuscript illustration it is also unusual for a narrative composition to consist of a single figure.

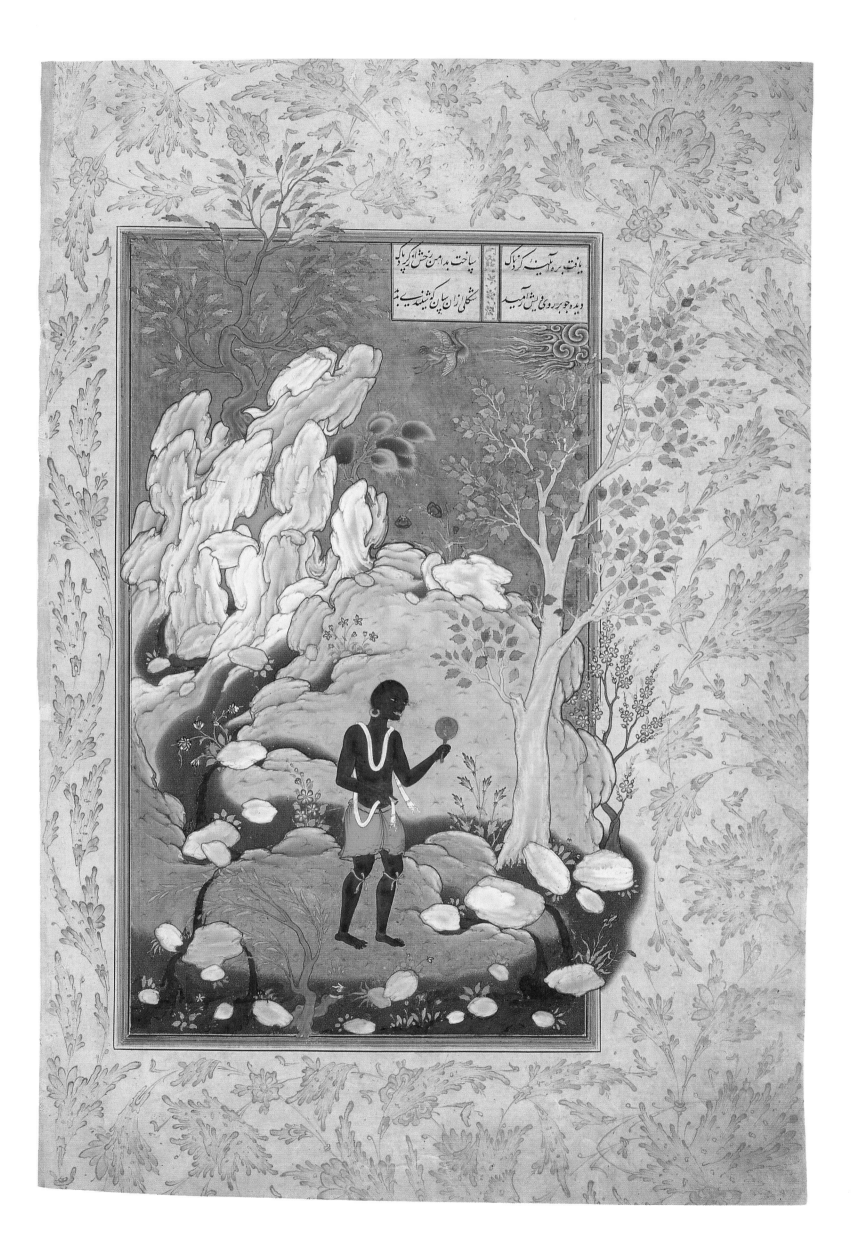

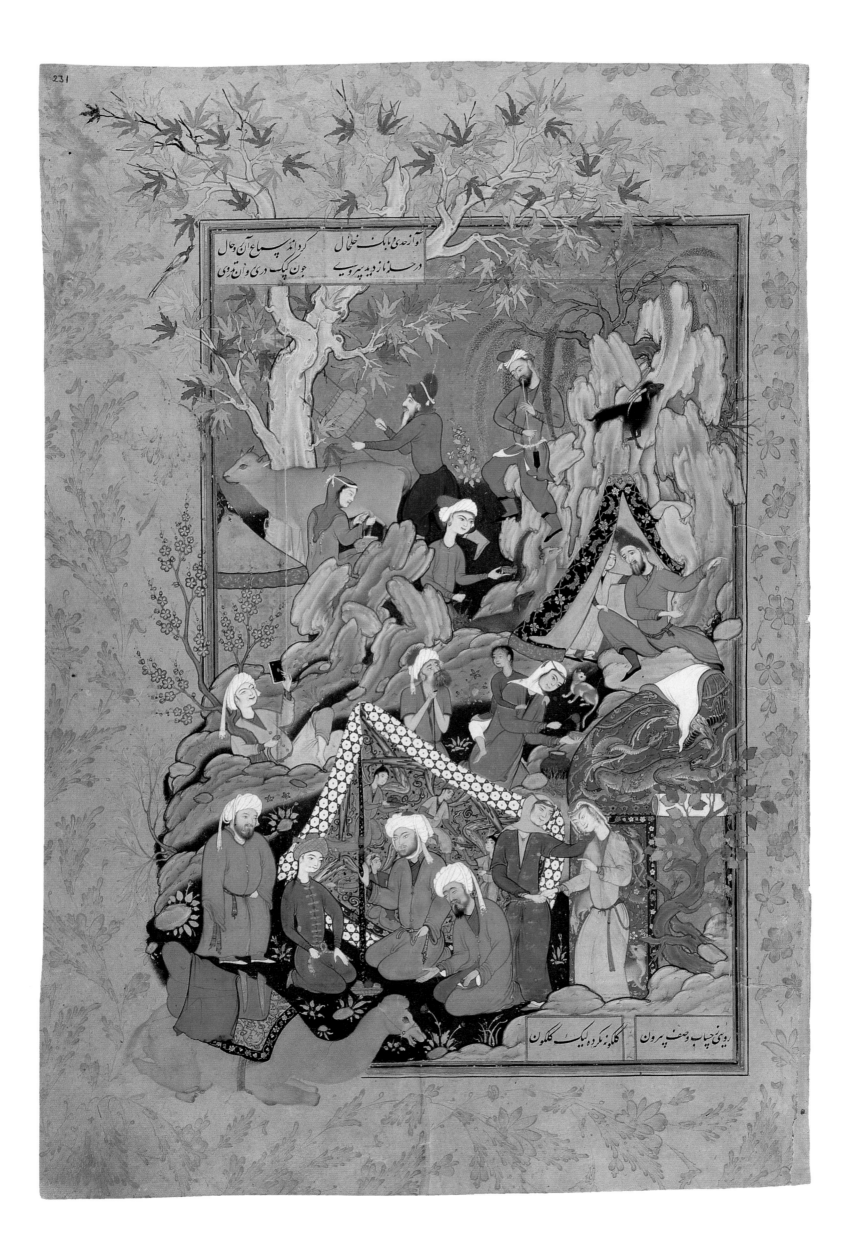

Folio 231a

QAYS FIRST GLIMPSES LAYLI

25.2 x 15.6 cm

Like Jami's other allegorical romances, his *Layli and Majnun* of 1484 belongs to an old poetic tradition of Arabic, and probably oral, origin. The poem concerns the tragic love story of Qays, a young man later called Majnun, and a young woman named Layli. Jami presents the star-crossed lovers as archetypes of Sufi love and their tale as an allegory for a spiritual quest. I write about love, says the poet, because love is the most inspired of all themes.

The encounter of Qays and Layli occurs in the foreground of a rocky landscape where Layli's tribe has pitched camp. The hopeful lover Qays kneels on a plot of grass at left, and his beautiful beloved emerges from a tent at the right. Qays seems to be accompanied by a short, rotund, and bearded gentleman who stands with one hand tucked into his waistband as if to support his impressive paunch. Layli, identifiable by fancy earrings and headdress as well as her hesitant demeanor, also has a companion who gently guides her forward.

The encampment scene contains many features that distract from the momentous meeting of Layli and Qays, on the one hand, and contribute to the composition's visual appeal on the other. These features include the large caparisoned camel kneeling in the left-hand margin, the four angels who hover inside the foreground canopy, the simurgh (a large mythical bird) attacking a dragon atop Layli's tent, and the various domestic vignettes that fill the upper part of the composition. Two specific figures in this illustration—the pipe player and the wool spinner—also appear in *A Depraved Man Commits Bestiality and Is Berated by Satan* (folio 30a). The styles of the two paintings differ considerably, however. Here the figures loom large in relation to the landscape, and their bodies exhibit odd proportions, as, for instance, the young boy riding piggyback, whose head and neck do not seem to belong to his torso, which in turn seems too short for his very long legs.

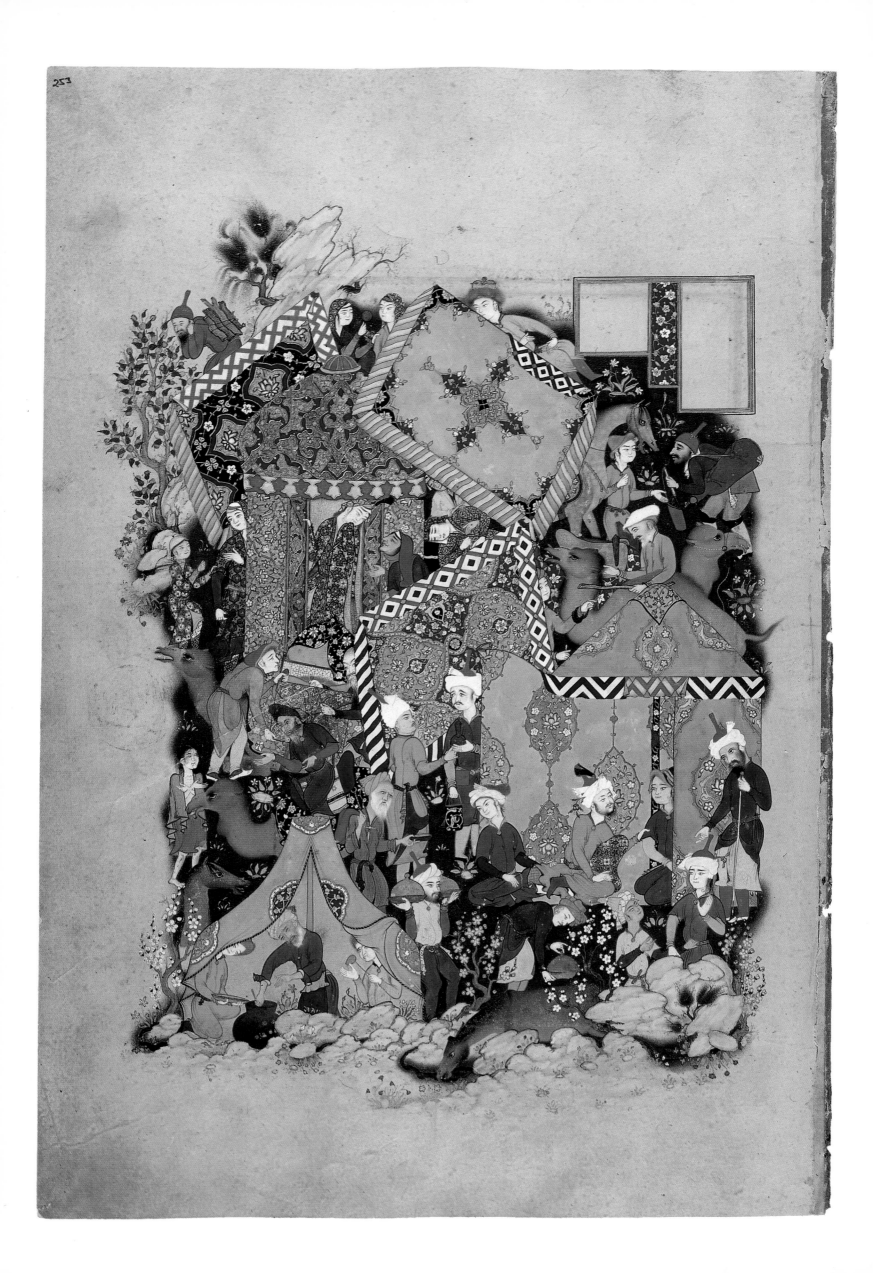

Folio 253a

MAJNUN APPROACHES THE CAMP OF LAYLI'S CARAVAN

23.5 x 19.5 cm

As in many powerful love stories, *Layli and Majnun* contains moments of great passion followed by incidents of rejection and despair. At one point the boy Qays loses his reason as a result of his overwhelming passion for Layli, a state comparable to the Sufi's ecstatic experience of God. Thereafter he bears the name Majnun (meaning "mad") and goes off to live in the desert where he becomes increasingly intimate with nature, another sign of his greater communion with the divine. One day he sees a tent camp at a distance and learns from a departing cameleer that this is the caravan of Layli's tribe, en route to Mecca. Majnun follows the caravan at a distance, trying to catch a glimpse of his beloved.

This encampment scene is without a doubt the most enigmatic illustration and most complicated, even confusing, composition in the Freer Jami. Its complex pictorial structure is anchored by a half-dozen brilliantly decorated tents and canopies that enframe and provide the backdrop for numerous slices of camp life, some very realistic and others quite puzzling. Wandering among the tents we come across a meal being cooked (with a boy blowing on a skewered victual for added verisimilitude), a camel being unloaded, a man lugging fagots, and a beggar holding out a bowl. We also encounter other activities, particularly in the upper left quadrant of the scene, that are difficult to interpret: a girl sleeping or fainting in the arms of a haglike older woman, a little girl in braids restraining a taller female who holds a ewer, and two girls exchanging a mirror. Many of the figures have distorted facial features, and their body parts often defy anatomical logic. Given this painting's jumbled juxtaposition of the mundane and the bizarre, it is easy to miss the conversation taking place at the left side between Majnun, depicted as an emaciated youth with a blue blanket around his shoulders, and the bearded man on camelback who confirms that the mad youth has found his heart's desire.

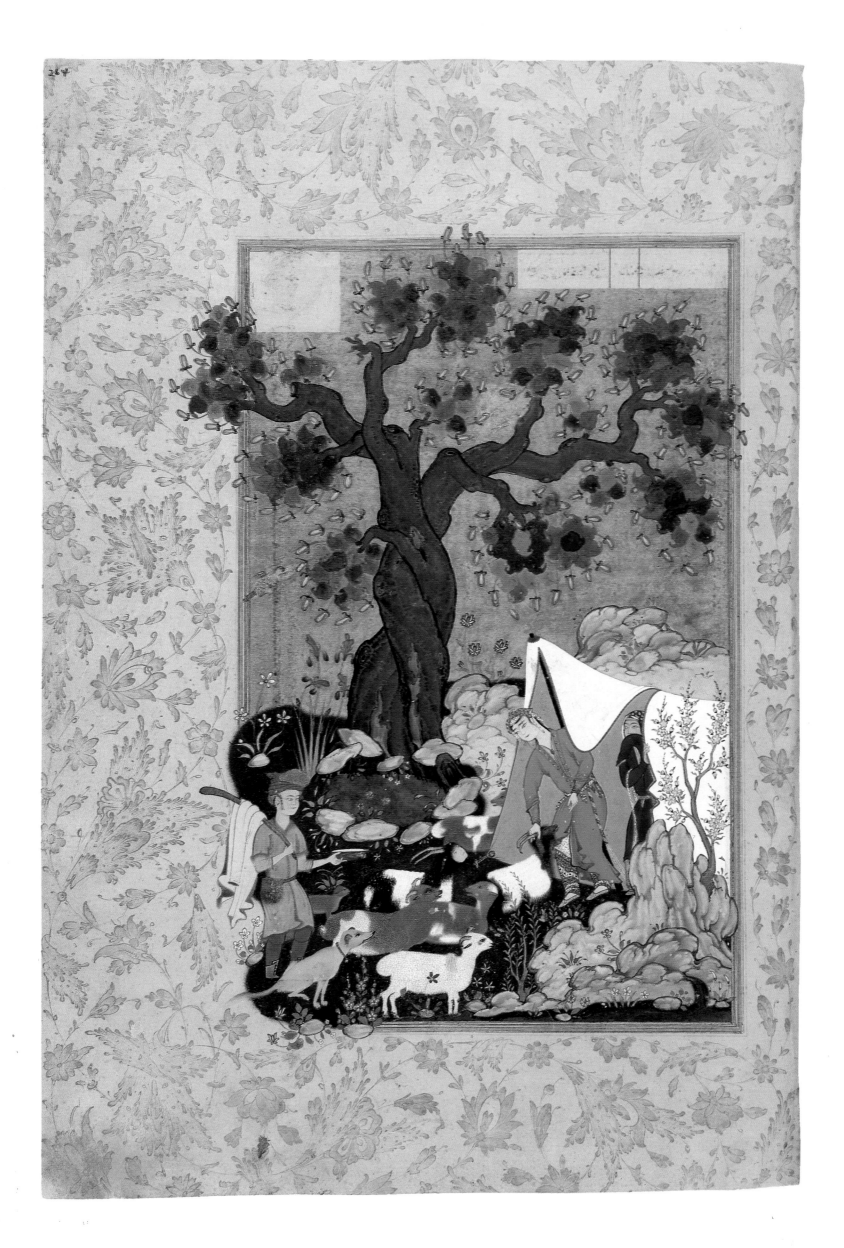

Folio 264a

MAJNUN COMES BEFORE LAYLI DISGUISED AS A SHEEP
23.3 x 14.5 cm

Majnun follows Layli's caravan to Mecca, where he stands next to his beloved for a brief moment. He then resumes his desolate wanderings in the desert, hoping to find a sheepskin that he can put on and join Layli's flock. Her herdsman pities the suffering youth and gives him a skin to wear as a veil. At this point in Jami's narrative Majnun is readily identifiable as an ascetic, since animal skin is the traditional Sufi symbol of those who have "left this world." The herdsman is the mediating *pir*, or spiritual guide, leading Majnun down the mystical path to union with the beloved.

Disguised in the sheepskin, which he calls a robe of honor, Majnun mingles with the flock and passes in front of Layli, whereupon he faints from emotion. Layli then takes Majnun in her arms and revives him.

This small painting is one of several in the Freer Jami lacking verses in the text blocks. The omission may be deliberate since the iconography of the illustration does not correspond to the verses that would have been written there and that tell, in part, of how Layli revived Majnun following his fainting spell. Here instead Majnun, his small face peering out from a horned skin of black and white fur, and the other animals seem to have just arrived in front of Layli. The young woman leans over to pat a black and white goat at the head of the flock. The texture of goat hair is so rich that we can almost feel the deep pile underneath Layli's hand. Perhaps this deft representation of fleece in so many different colors, patterns, and layers was intended to emphasize the explicit Sufi imagery and meaning of *Layli and Majnun*.

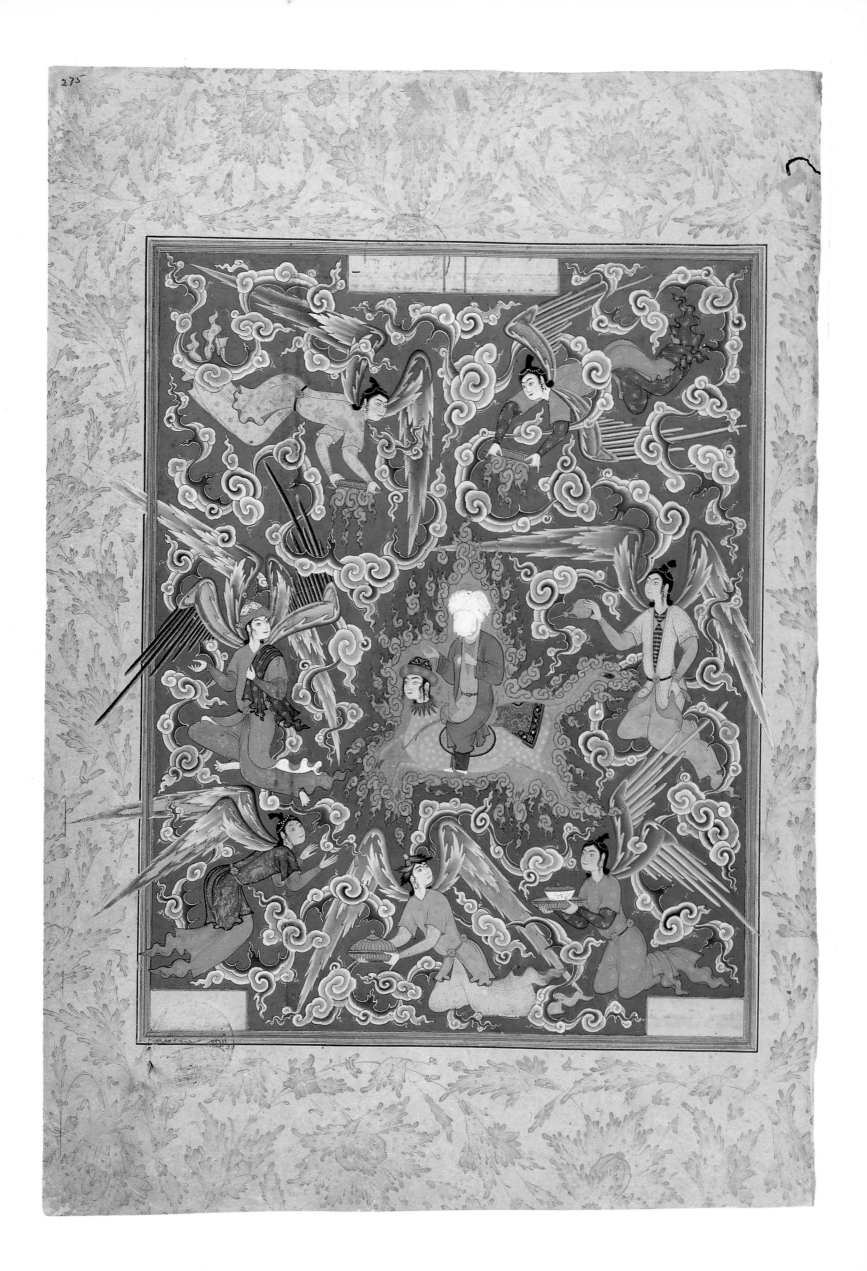

Folio 275a
THE MIʿRAJ OF THE PROPHET
23.3 x 17.6 cm

The prologue to the seventh and final *masnavi* of the *Haft awrang*, entitled the *Khiradnama-i Iskandari* (Iskandar's book of wisdom), begins with passages extolling the Prophet Muhammad. Jami's praises form a general panegyric on the Prophet's supremacy in various roles and realms and lead directly to a description of the *miʿraj*, Muhammad's miraculous ascension to heaven first mentioned in the Koran. Jami begins his rendition with an extended description of the luminosity of night and of Muhammad's human-headed steed Buraq as miraculously bright, beautiful, and swift. This section is followed by a short account of Muhammad's flight on Buraq from Mecca to Jerusalem while "the planets gathered around him and scattered coins in his path." The poet them compares the Prophet to the sun, planets, and other celestial bodies and casts his glorious qualities and achievements in images related to the scattering of gems.

Like the poetic text it accompanies, this Freer Jami illustration follows a well-established iconography for the representation of the Prophet's ascension to heaven. His face covered by a short white veil as a sign of sanctity, Muhammad rides Buraq across a bright blue sky, surrounded by angels and clouds. The Prophet's celestial escorts include the archangel Gabriel and six other angels who fly and float on brilliant, multicolored wings. Two angels swoop down from on high bearing golden platters and pouring golden flames, while a third hovers at the rear and sprinkles Muhammad and Buraq with rosewater. In general the depiction of the angels, including their positions, hairstyles, and clothing, fits within an artistic tradition familiar from sixteenth-century Iranian and Turkish manuscript illustrations and album drawings. Garlands of knotted clouds weave and swirl through the exalted company to further animate the scene.

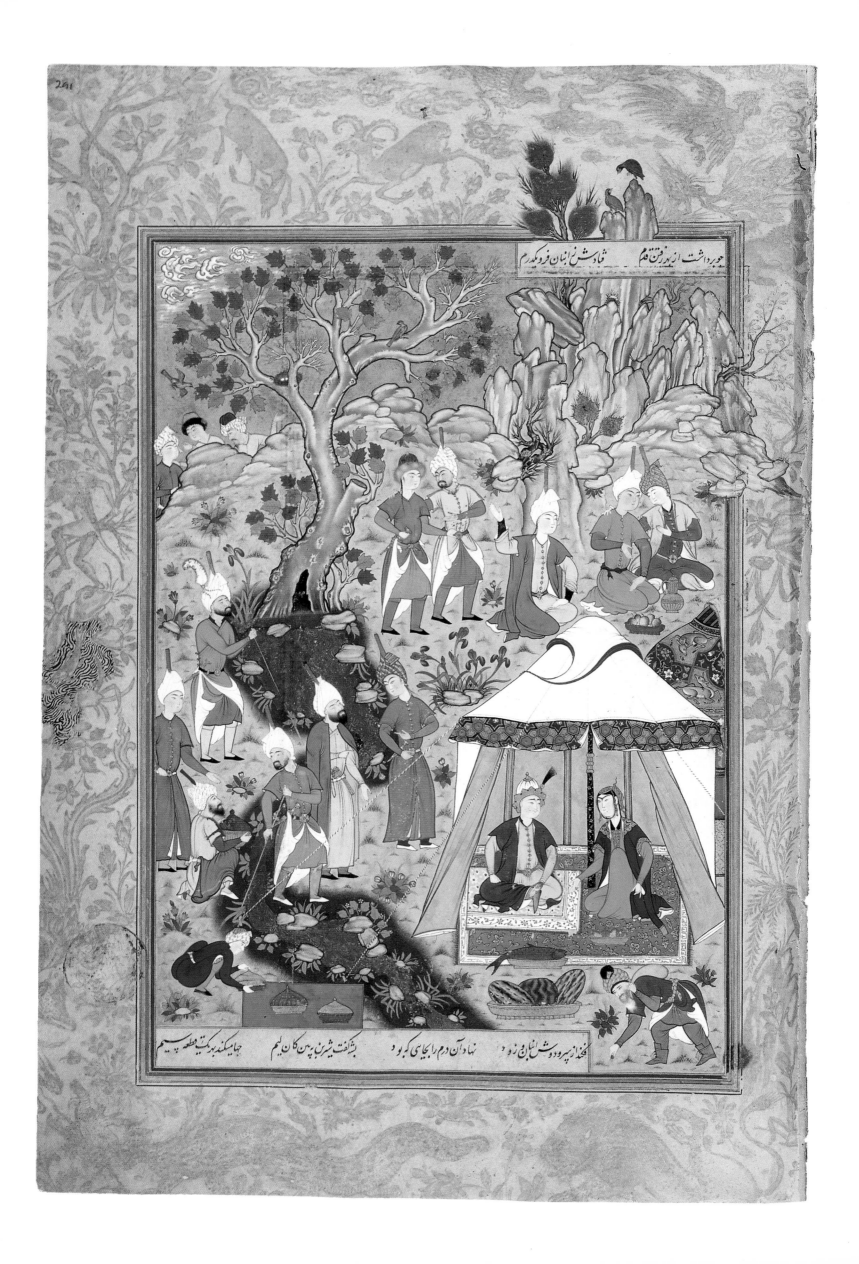

Folio 291a

KHUSRAW PARVIZ AND SHIRIN DEAL WITH THE FISHMONGER
25 x 17.2 cm

Like *Salaman and Absal*, *Khiradnama-i Iskandari* is a more or less continuous narrative punctuated with moralizing anecdotes. And also as in *Salaman and Absal*, women are the subject of harsh poetic criticism. One of the *Khiradnama* anecdotes concerns King Khusraw Parviz and his wife Shirin who are presented with a beautiful fish by a fishmonger wishing the royal couple well. The king is so pleased that he orders his treasurer to reward the fishmonger with thousands of coins. Shirin rebukes her husband for this excessive generosity and advises him to get his money back by asking if the fish is male or female. Whatever way the fishmonger replies, Shirin continues, Khusraw Parviz should say that it is unlawful to eat such a fish and then require the return of his reward. When the question is put to the fishmonger he answers that the fish is neuter. This clever reply so amuses the king that he orders the amount of the reward doubled. As the fishmonger walks away with a large sack, one coin falls out and he bends over to retrieve it. Shirin becomes enraged at this demonstration of miserliness and tells the king that he should demand the return of the entire sack. In his defense the fishmonger explains that he picked up the errant coin because it has the king's name stamped on it and he does not want it to be ground into the dirt. Khusraw Parviz again rewards this fine reply and concludes that "when something is done at a woman's command it is loss upon loss and disaster upon disaster."

The principal action of the scene takes place in the foreground where the king and queen converse and the fishmonger picks up the fallen coin. The beautiful fish rests in a platter in front of the royal pair, and attendants prepare vessels filled with coins. The rest of the composition is filled with courtiers of various ages who amuse themselves in the extensive landscape and pay virtually no attention to the pithy exchanges among the king, queen, and fishmonger.

Folio 298a

ISKANDAR SUFFERS A NOSEBLEED AND IS LAID DOWN TO REST
23.8 x 16.7 cm

Alexander the Great occupied a significant position in Near Eastern history and literature well before the Muslim era, and his fabulous exploits as adventurer, hero, monarch, philosopher, and even prophet remained legendary throughout the Islamic world even until modern times. Perhaps nowhere did Alexander—or Iskandar as he is known in Iran—exercise greater fascination than in medieval Persian literature, and *Khiradnama-i Iskandar* is but one of various poetic renditions written long before Jami composed his seventh and final *masnavi* around 1485.

The last part of Jami's poem narrates events leading to and following Iskandar's death. A wise man has prophesied that the young hero would die while traveling in a land made of iron under a sky of gold. One day during his military campaigns Iskandar rides to a desert, where he is overcome by the blazing heat and suffers a continuous nosebleed. Attendants help the king down from his horse and spread his armor for a carpet (the iron ground) and his shield for shade (the golden sky). As he lies unconscious, Iskandar hears the voice of an angel who whispers that this is the place where he will die. After regaining consciousness, he dictates a letter to his mother that contains an extended metaphor about a tree (Iskandar) that is planted and watered by a *dihqan* (his mother). After many years the tree is blown away by a fierce wind. Iskandar then instructs his mother not to torment herself with mourning rituals and not to let mourners become overwhelmed with emotion at his funeral. He concludes with a discourse on the transcendence of earthly bonds and then summons attendants to help him "open the gate to the court of union."

Like the text it illustrates, this painting anticipates Iskandar's death by incorporating elements of the funeral soon to come. The bearded king lies at the foot of a large tree, his shut eyes signaling his state of prostration and impending death. Immediately in front is a large, confused mass of animals and men, including several mourners who express their grief in grimacing faces, bared chests, and ritualistic gestures. Even the horses participate in the drama through combative displays. The large tree in the background (a part of the composition that has, however, been partially repainted) refers to the sapling that Iskandar uses metaphorically in his letter as an emblem of life and death. Its five thick, truncated branches terminating in flames add yet another powerful element to a scene already fraught with pathos.

The imminent death of a great Iranian hero who overcomes many obstacles to achieve union with God makes an undeniably dramatic finale to Sultan Ibrahim Mirza's *Haft awrang* and leaves us with the distinct sense that a particular personal purpose lies behind the manuscript's final illustration.

1540 April	Birth of Sultan Ibrahim Mirza, son of prince Bahram Mirza and Zaynab Sultan.
1549 October	Death of Bahram Mirza; Sultan Ibrahim Mirza moves to court of his uncle, Shah Tahmasp.
1554–55	Sultan Ibrahim Mirza appointed governor of Mashhad; prince and his entourage leave for Mashhad late February 1555 and arrive in Mashhad 19 March 1556.
1556 early August	Rustam-Ali completes transcription of *Tuhfat al-ahrar*.
early October	Shah-Mahmud al-Nishapuri completes transcription of *Subhat al-abrar* in Mashhad.
October	Malik al-Daylami completes transcription of *Silsilat al-dhahab* (first section) in Mashhad.
1556–57	Mir-Munshi appointed to serve as senior counselor and chief financial adviser to Sultan Ibrahim Mirza and goes to Mashhad with his eleven-year-old son, Qazi Ahmad.
1557 11 May	Muhibb-Ali completes transcription of *Yusuf and Zulaykha* in Mashhad.
June–July	Malik al-Daylami completes transcription of *Silsilat al-dhahab* (second section).
August–September	Tahmasp agrees to marriage of his daughter Gawhar-Sultan Khanim and Sultan Ibrahim Mirza.
1559 June–July	Malik al-Daylami completes transcription of *Silsilat al-dhahab* (third section) in Qazvin.
1559–60	Sultan Ibrahim Mirza finds gold and silver objects after a flood near Mashhad and sends them to Shah Tahmasp.
1560 March–June	Wedding party of Gawhar-Sultan Khanim arrives in Mashhad.
1560–61	Ayshi ibn Ishrati completes transcription of *Salaman and Absal*.
1561–62	Mir-Munshi removed from office.
1563	Sultan Ibrahim Mirza appointed to serve as governor of Ardabil in northwestern Iran. Shah Tahmasp then withdraws this appointment and instead appoints the prince as governor of Qa'in in Khurasan province, northeastern Iran.
1564–65	Sultan Ibrahim Mirza participates in two military campaigns in Khurasan province, the second involving a battle in Herat.
1565 early May	Muhibb-Ali completes transcription of *Layli and Majnun* in Herat.
1565–66	Sultan Ibrahim Mirza reinstated as governor of Mashhad.
1566–67	Sultan Ibrahim Mirza removed from office in Mashhad a second time and appointed governor of Sabzivar, in Khurasan province.
1574 April–May	Sultan-Muhammad Khandan completes transcription of a volume of the *Naqsh-i badi'* in Sabzivar. This is the only manuscript other than the *Haft awrang* documented as having been made "by order of the *kitabkhana* of . . . Sultan Ibrahim Mirza."
22 December	Sultan Ibrahim Mirza recalled to Safavid court at Qazvin.
1575 9 March	Sultan Ibrahim Mirza appointed grand master of ceremonies at Safavid court.
1576 14 May	Death of Shah Tahmasp.
21–28 May	Sultan Ibrahim Mirza greets the new shah, his cousin Isma'il II, near Qazvin.
1577 23/24 February	Sultan Ibrahim Mirza put to death by order of Isma'il II.
4 June	Death of Gawhar-Sultan Khanim, wife of Sultan Ibrahim Mirza.

Canby, Sheila R. *Persian Painting*. London: British Museum Press, 1993.
This succinct survey of the history of Persian painting places the
illustrations of the Freer Jami in stylistic context.

Dickson, Martin Bernard, and Stuart Cary Welch. *The Houghton
Shahnameh*. 2 vols. Cambridge, Mass.: Harvard University Press, 1981.
This monumental publication focuses on the magnificent copy of the
Persian national epic made for Shah Tahmasp, with a vital interest in other
related works of art including the Freer Jami. Drawing on a wealth of
Safavid sources and exhibiting an incomparable use of connoisseurship, the
authors identify and discuss the artists responsible for the illustrations in
Shah Tahmasp's *Shahnama* and Sultan Ibrahim Mirza's *Haft awrang* and
explore the artistic tastes and motivations of these two important Safavid
patrons.

Qazi Ahmad. *Calligraphers and Painters: A Treatise by Qadi Ahmad, Son of
Mir-Munshi (circa* A.H. *1015/*A.D. *1606)*. Translated by V. Minorsky.
Washington, D.C.: Freer Gallery of Art, 1959.
Entitled *Gulistan-i hunar* (Garden of the arts) in Persian, this is the best-
known, and most frequently cited, primary source for Safavid artists and
patrons. The author's father was senior counselor to Sultan Ibrahim Mirza
in Mashhad, and Qazi Ahmad was connected from childhood with the
artistic circles around the prince. His treatise describes (generally in
quite inflated terms) Sultan Ibrahim Mirza's interests and accomplishments
as well as the lives and careers of various artists who worked at the prince's
kitabkhana.

Simpson, Marianna Shreve. *Sultan Ibrahim Mirza's Haft awrang: A Princely
Manuscript from Sixteenth-Century Iran*. New Haven and Washington, D.C.:
Yale University Press and Freer Gallery of Art, 1997.
This is the first detailed study of the Freer Jami that seeks to explain the
manuscript's material and artistic contents, pictorial program, methods of
production, and meaning. It also contains sections devoted to Sultan
Ibrahim Mirza and the artists who worked on the *Haft awrang*, including
discussions and listings of each artist's oeuvre.

Welch, Anthony. *Artists for the Shah: Late Sixteenth-Century Painting at the
Imperial Court of Iran*. New Haven: Yale University Press, 1976.
Although the primary focus of this book is the last quarter of the sixteenth
century and particularly artistic developments during the reign of Shah
Abbas (1588–1629), it also presents a useful overview of Safavid painting
throughout the century. The fifth chapter on "personalities and patronage"
includes a long discussion of Sultan Ibrahim Mirza and the artists
responsible for the prince's *Haft awrang*.

Welch, Stuart Cary. *Persian Painting: Five Royal Safavid Manuscripts of the
Sixteenth Century*. New York: Braziller, 1976.
This deceptively small book summarizes many of Welch's ideas about the
history and forms of Safavid painting and the seminal patrons and painters
of the period. It contains the first color reproductions and descriptive
comments of a selection of Freer Jami illustrations.

Note: Numbers in italics refer to the pages on which illustrations appear.